IMAGES
of America

TACOMA'S
SALMON BEACH

Roger Cushman Edwards

Sept. 18, 2015

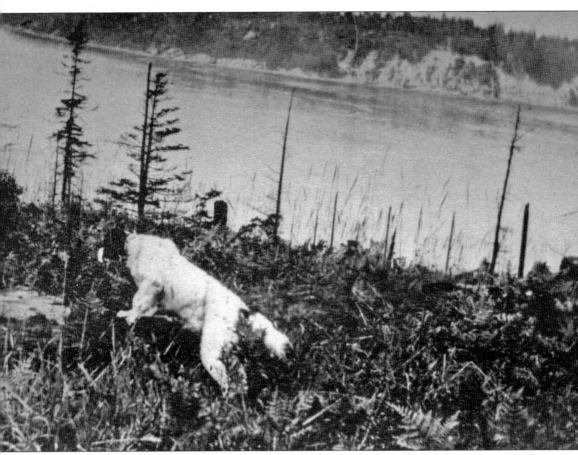

One mile west of Ruston, "Bird" looks across the Tacoma Narrows toward Point Evans on the Kitsap Peninsula as his master, Bill Allie, prepares to descend the steep trail to the beach in 1917. The owner of this high bank view property, John S. Baker, envisioned a fancy development but he did not own the tidelands. After World War I, he lost interest, madrona replaced grass, and the fishing shacks on Salmon Beach remained hidden from most Tacomans for many decades. Now this area is occupied by a gated community.

ON THE COVER: In 1913, Beulah Shaw paddles her Native American canoe in front of Camp Dixie, south of the general store in the distance. Maude C. Whitlock, an early Tacoma optometrist, prefers a skiff rented from the Salmon Beach Boathouse. Beach camping began with tents on wooden platforms, pictured at right. More industrious fishermen and their families built one-room fishing shacks. (Courtesy of Nancy Reed Mish.)

JAMES J. MURPHY, *the author of several pioneering studies in the history of rhetoric, is a professor emeritus at the University of California–Davis. His primary research area is the history of language use, including rhetoric, grammar, and literature.*

CLEVE WIESE *teaches writing and journalism at Worcester State University. His research focuses on the intersections between historical rhetorics and contemporary writing pedagogy.*

IMAGES
of America

TACOMA'S
SALMON BEACH

Roger Cushman Edwards

ARCADIA
PUBLISHING

Published by Arcadia Publishing
Charleston SC, Chicago IL, Portsmouth NH, San Francisco CA

Printed in the United States of America

Library of Congress Catalog Card Number: 2005936983

For all general information contact Arcadia Publishing at:
Telephone 843-853-2070
Fax 843-853-0044
E-mail sales@arcadiapublishing.com
For customer service and orders:
Toll-Free 1-888-313-2665

Visit us on the Internet at www.arcadiapublishing.com

CONTENTS

ACKNOWLEDGMENTS

A March 1947 telephone directory, discovered in 1971, started the author's interest in finding former residents. Of the 20 names listed for Salmon Beach, only George J. Girard was still "active," even though his cabin burned down in 1969. George and his late wife, Hortense "Hoyt," bought their cabin in 1931, so he helped find many former neighbors. Several other names were found in old city directories, loaned by the Tacoma Public Library staff. Notes of telephone calls and interviews were typed single-spaced on yellow paper using my grandmother's 1928 Royal portable. I'm grateful that Virginia Hartman catalogued my notes on index cards. Because Salmon Beach cabins were considered just fishing shacks, the county tax assessor had no ownership records until 1951. Based on my notes, I charted cabin ownerships going back before World War I. All research was done without a personal computer. Memories don't wait for technology to catch up, and every newspaper obituary represented a historian's opportunity lost forever.

Former residents who were willing to talk with a total stranger deserve praise. Some allowed me to make copy negatives of their family photographs. Ceta Wendt Condon's collection of glass plate negatives made the best prints. Hazel and Beulah Carr saved the largest collection of vintage World War I snapshots. Other significant sources of photographs were Florence Sackett, Nancy Reed Mish, Charles Chase, Bonita Turner Ohiser, Marjorie Leftwich Thorpe, Dorothy Kowalchuk Scott, Barbara Stamey Nolen, Art and Bobbie Hemphill, Ellen Olson Allie, Minnie Bartlett Lytle, Billie Jean Hager Hagenau, Ercil and Alice Bennatts, Pearl Lusha Young, Marie Niles, and Roy "Sonny" LaPlante. Sometimes the smallest snapshot can be priceless, such as Violet Crooks Trask's photograph of her father and uncles trying to pour whiskey down a salmon.

Special recognition is owed to Virna Haffer, a professional photographer who owned a summer cabin at Salmon Beach. Just before her death in 1974, she donated 60 color slides and a large box of black-and-white prints. And thanks to Ron Karabaich and Don Jutte of the Old Town Photo Studio; Dr. Caroline Gallacci, Tacoma's historian; and the author's companion, Marilyn Mahoney.

Landmarks in Rhetoric and Public Address

INTRODUCTION

By 1900, Tacoma's Commencement Bay was lined with lumber mills and wharves. The only place for summer camping was along Tacoma's western edge, known simply as the Narrows. In 1906, Andrew and Thea Foss purchased the tidelands between the Government Meander Line and the Inner Harbor Line south of Point Defiance Park. Henry O. Foss, youngest son of Andrew and Thea Foss, towed the family's two-story boathouse, built in 1891, from the city (renamed Thea Foss) Waterway to their newly purchased tidelands. Charlie Ziegler, who operated the general store built in 1909, later changed the name to Salmon Beach. After 1914, Andrew and Thea's three sons, C. O., Wedell, and Henry, formed the Foss Launch and Tug Company, now Foss Maritime. Their father, Andrew Foss, was put in charge of the Salmon Beach Boathouse and Store. Little fishing shacks or tent platforms, built on wood posts and stuck in the gravel beach, soon dotted the shoreline. When the Northern Pacific Railway destroyed the beachfront south of the Nelson Bennett tunnel in 1910, beach campers filled the remaining campsites.

In 1917, upland landowner John S. Baker hired the Olmsted Brothers of Brookline, Massachusetts, to subdivide his acreage into choice residential sites (Olmsted Brothers, Job No. 6454). When the landscape architect asked about the little camps and summer cottages, Baker explained that these campsites were only leased for the summer season at $10 each. If the Foss tidelands had been sold to the wealthy Mr. Baker after the death of Andrew Foss in March 1937, Salmon Beach would not exist today. Henry Foss refused to sell the tidelands and actually leased them to the community for several years after Baker tried to evict everybody. Only after abandoned buildings became a liability, did he reluctantly hired a local resident to tear down the old Foss Boathouse in 1963. Then the vacant store, used as a community clubhouse, was torn down in 1969. Finally, Henry Foss provided funds to the Metropolitan Park District of Tacoma to purchase the tidelands in 1971.

During Prohibition, the springs near the bottom of the steep hillside made these shacks ideal for moonshine stills. The Great Depression changed these shacks into year-round homes, especially after power lines brought electric lights to the beach in 1934. Some energetic residents built comfortable cottages over Puget Sound with lumber used to form the new bridge towers of "Galloping Gertie," the bridge that collapsed on November 7, 1940. Fishermen could sell their fresh salmon for 4¢ per pound. Shipyard workers during both world wars rented every available cabin, because land still remained very cheap. Then in 1949, the worst earthquake of the 20th century caused a major landslide just north of the cabins, and Baker decided to evict all persons and property from Salmon Beach by December 31, 1949.

The community organized an improvement club to fight eviction in court. Baker died in 1955, but the Baker Investment Company, disguised as the Narrows Realty Company, finally received clear legal title to the tidelands under the cabins in 1958. Short-term leases helped pay the substantial property taxes of Baker's heirs until the 1970s. Since Salmon Beach had no sewers, Tacoma's Community Improvement Program rated each cabin not fit for habitation. The entire community was again faced with eviction. The turning point was a public hearing on Tacoma's

Master Plan for Shoreline Development on December 12, 1973. The Tacoma Planning Commission decided that instead of forcing removal, Salmon Beach should be allowed to remain as one of Tacoma's three historic shorelines, along with Old Tacoma and City (later Thea Foss) Waterway. This major policy change coincided with the first of seven historical newsletters printed between 1973 and 1977 for current and former residents, leading to the first reunion in 1975. The entire community was designated a Washington State historic district in 1976, and one original cabin (No. 97) was placed on the National Register of Historic Places in 1977.

Nearly all cabins have been remodeled or rebuilt beyond recognition. Only photographs remain of the fishing shacks and the old-timers that lived here. Fortunately, a nationally known photographer and author, Virna Haffer, took many photographs with her Hasselblad camera 50 years ago, just before the closing of the Foss Boathouse and General Store. All the Foss commercial buildings are now gone, and even the salmon are nearly gone.

One

FAMILY CAMPING AT TACOMA NARROWS

1903–1918

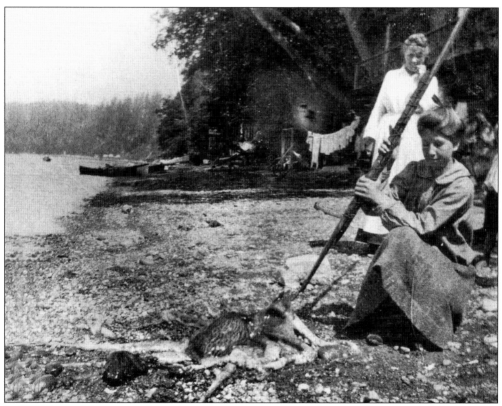

In 1905, Laura Mojean watches a live octopus wrap its tentacles around an oar while her mother watches nervously. A person could camp anywhere on the Tacoma Narrows before the Northern Pacific Railway built its new shoreline route over the tidelands. After 1910, only a 4,000-foot strip of tideland was left between Point Defiance Park and the Nelson Bennett Tunnel. (Courtesy of Laura Mojean Dobson.)

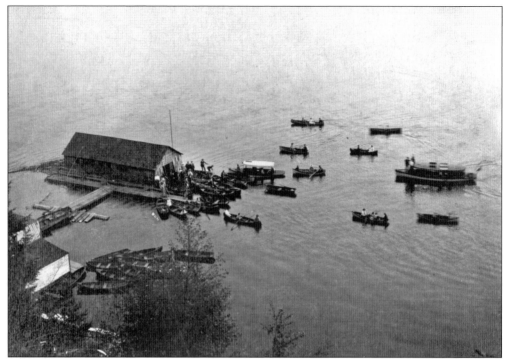

Henry Foss remembered towing his parent's boathouse with the five-horsepower naphtha launch, at right, on Easter Sunday 1906. By 1908, the rowboat-rental business was so popular that a floating shed was moored offshore during the summer. The following year, Foss built a larger two-story building for boat storage, which later became a general store. (Courtesy of Henry O. Foss.)

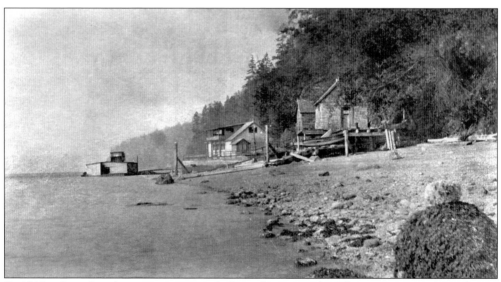

By 1909, a few cabins began to sprout on driftwood posts south of the Foss Store and Boathouse. The one-room cabin in the foreground is now the front room of cabin No. 39, the oldest cabin still on Salmon Beach, which is now being restored by the author. (Courtesy of Hazel and Beulah Carr.)

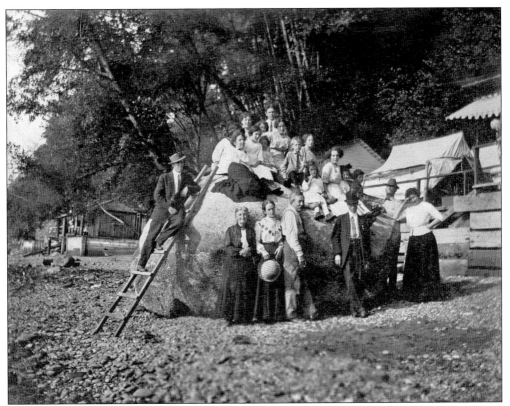

In 1912, Fred Carr gathered his family around this huge boulder that was painted white as an early navigation marker. This landmark boulder is still there, although covered by decking between cabins No. 56 and No. 58. (Courtesy of Hazel and Beulah Carr.)

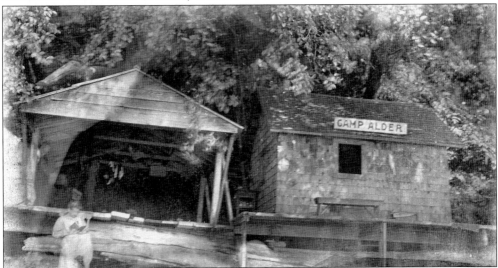

According to Hazel Carr, her father built the first camp at Salmon Beach in 1903. Camp Alder had the advantages of a freshwater spring underneath the shade of overhanging alders. Winter storms frequently sent trees crashing to the beach. If someone's cabin was destroyed, the person just came back and rebuilt the following summer. (Courtesy of Hazel and Beulah Carr.)

Why would a person build a camp behind this huge fallen tree? Maybe that explains why some camps were just wooden platforms constructed only large enough for a tent. (Courtesy of Hazel and Beulah Carr.)

Of course, there was no trail to the camp either, as the only way to access it was if a person walked along the beach when the tide was out far enough. This explains why most camps were built as close to the bank as possible, in spite of the risk that the diurnal tide can vary from a winter high of +14.5 feet to a low of -3.5 feet. (Courtesy of Hazel and Beulah Carr.)

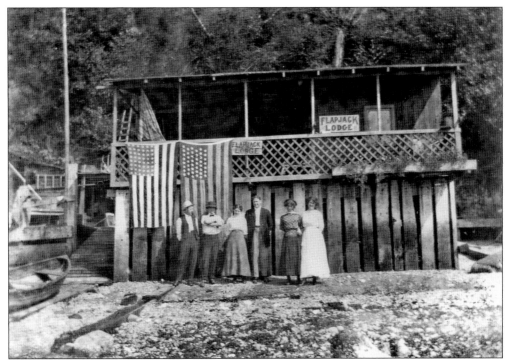

South of Camp Alder was Flapjack Lodge, built by Hiram "Heimie" Wendt. Trees brought down by landslides destroyed both Camp Alder and Flapjack Lodge in 1914. This Fourth of July family gathering shows both an old 45-star and a new 48-star flag. As a postal carrier, getting used flags from the post office was no problem for Hiram. (Courtesy of Ceta Wendt Condon.)

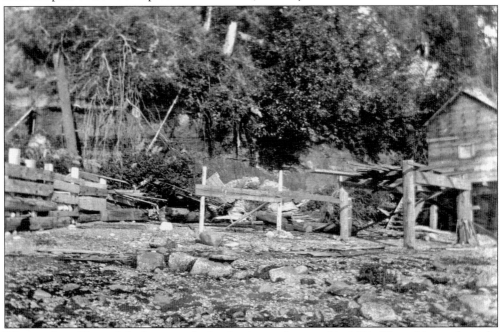

This is where Flapjack Lodge was rebuilt after it was destroyed in 1914. The cabin on the right survived, as pictured on the following page. (Courtesy of Hazel and Beulah Carr.)

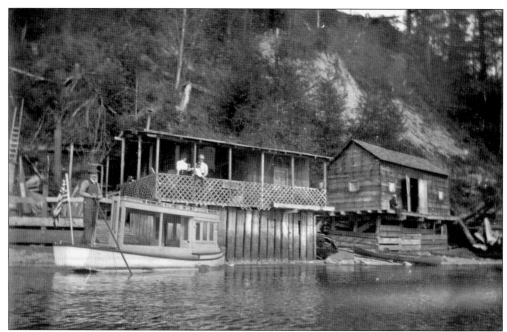

The tide covers the beach in front of Flapjack Lodge. A bare hillside south of their cabin indicates a recent mudslide. The enclosed boat in the foreground is certainly inappropriate for fishing, but it might have been the *Butcher*, owned by Richard Uhlman of Old Town. During three months of summer, he sold meat and groceries to vacationers camping on the Sound. (Courtesy of Ceta Wendt Condon.)

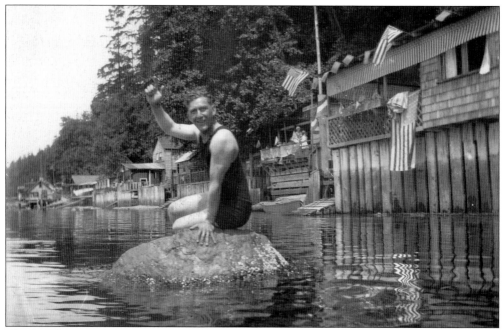

The handsome man waving his arm on this rock could not imagine how all these summer cabins could be destroyed by 1925. Only the rock remains today near No. 49. (Courtesy of Ceta Wendt Condon.)

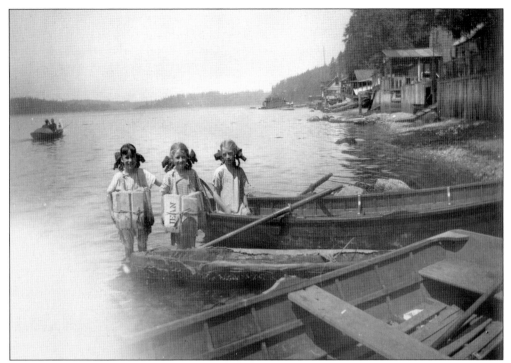

Wrapped in tarred canvas, an old Native American dugout canoe lies on the beach between two new rowboats. Taking no chances, two of the girls wear heavy cork life preservers. (Courtesy of Ceta Wendt Condon.)

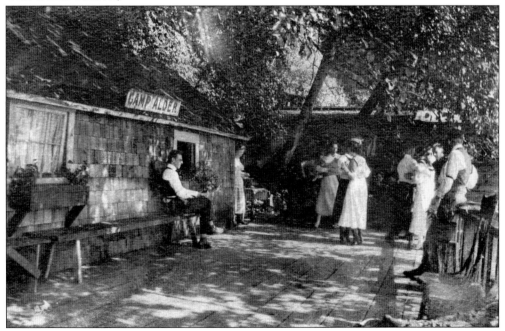

The second Camp Alder had a large deck ideal for dancing in 1915. Music was provided by a portable Victrola that played 10-inch Columbia records near the back corner of the deck. (Courtesy of Hazel and Beulah Carr.)

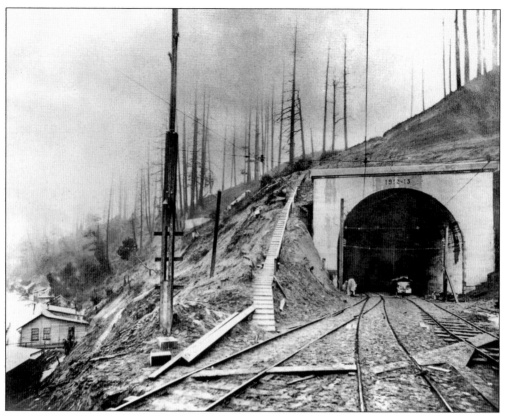

The Nelson Bennett tunnel marks the south end of Salmon Beach, known today as Tranquilly Gap. Although burned, the trees around the tunnel were left standing. The alders have now been replaced by madrone. The double-track rails have been replaced by a single rail down the center. (Courtesy of Richards Studio Collection, Tacoma Public Library.)

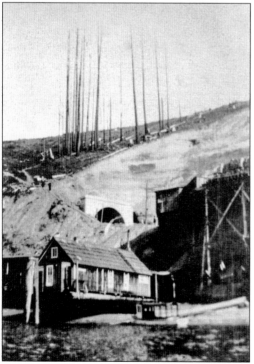

The spur track, pictured at above left, was supported by a temporary platform called falsework. This allowed tunnel workers, called "sand hogs," to dump excavated material directly on the beach along the right-of-way. Civil engineers like H. W. Tremaine and John C. Guyon lived at the Narrows in cabins built on giant logs and floated to the tunnel construction site. (Courtesy of Adolph Gertig.)

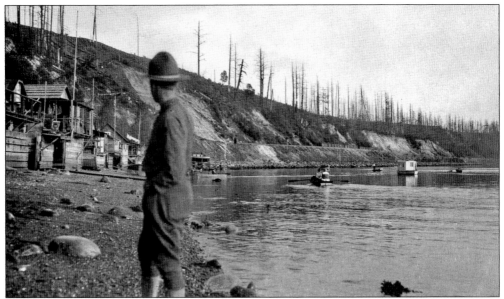

Oscar Wall, who owned Old Tacoma Shoe Store, camped along the Narrows before the railroad destroyed it. When he returned in 1918, while stationed at Camp Lewis (now Fort Lewis), this is how he observed the south end of Salmon Beach. (Courtesy of Oscar Wall.)

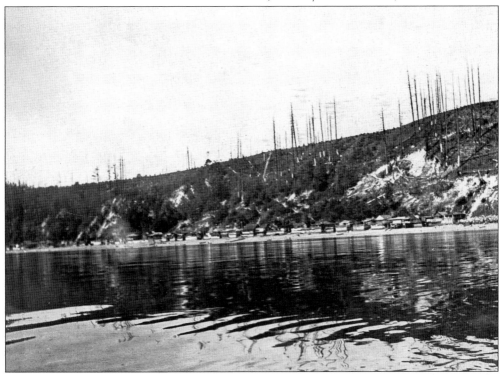

Here's another view of the devastated hillside above the south end of Salmon Beach in 1916. Children of fishermen have vivid memories of fighting brush fires with wet burlap sacks to save this string of little fishing shacks on the beach below the burning hillside. (Courtesy of Hazel and Beulah Carr.)

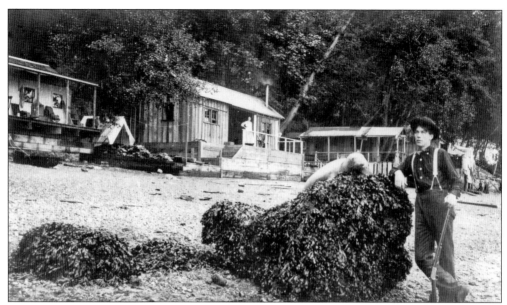

Fishermen have always had to compete with hungry seals. This man poses with his shotgun next to the trophy seal on the rock beside him. (Courtesy of Ceta Wendt Condon.)

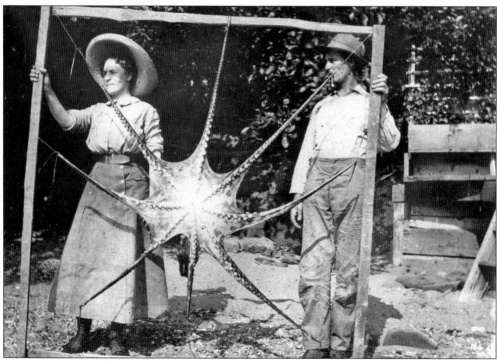

A giant octopus tied to a curtain stretcher makes a good trophy photograph as well. (Courtesy of Ceta Wendt Condon.)

Ed and Anna Olson of Ruston spend a quiet Sunday afternoon on their front porch. In 1915, they paid $150 for the camp before selling it to Anna's sister Lillie and her husband, Harry McCammant, who later became mayor of Ruston. (Courtesy of Purl and Ellen Allie.)

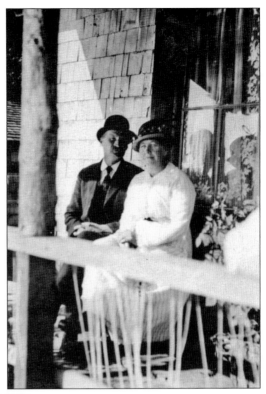

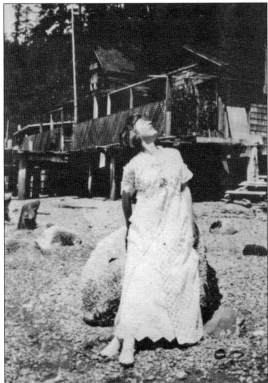

The sun warms the Olson's daughter Ellen. She married Purl Allie, of Ruston, who sold groceries and meat at Fifty-first and Winnifred Streets, a Ruston landmark. When her daughter Ruth married Leonard Peltier, the store was renamed the L and R Market, which is Don's Market today. (Courtesy of Purl and Ellen Allie.)

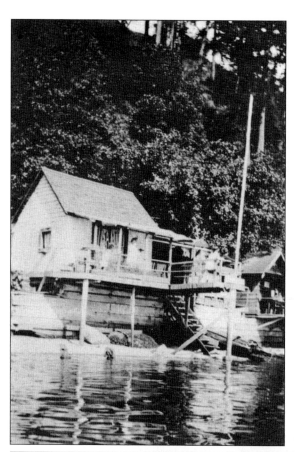

Here is another photograph of the same camp shown on the previous page, now No. 39. The pier, supported by a single skinny pole, would not last long, but the north side of the cabin is unchanged today. (Courtesy of Purl and Ellen Allie.)

Next to Olson's Camp is Sylvan Lodge, looking south toward Camp Wanaton. Note the overhanging alder trees that provide shade. Unfortunately, wind and rain are capable of toppling those alders. (Courtesy of Ellen Olson Allie.)

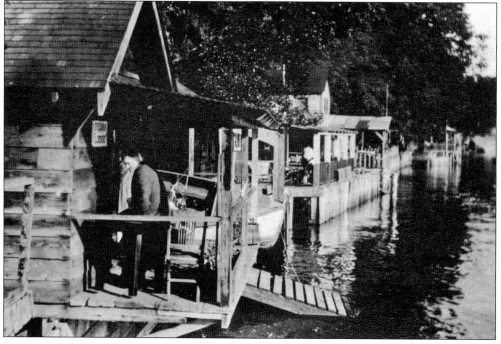

Lloyd B. "Bob" Coen shows off his new Koban rowboat motor in front of Camp Wanaton in 1916. The Koban was one of the first two-cycle engines with magneto ignition. To start it, a person would spin the wheel on top, back and forth, until it fired; letting go quickly was essential to avoid a broken wrist. (Courtesy of Teresa Coen.)

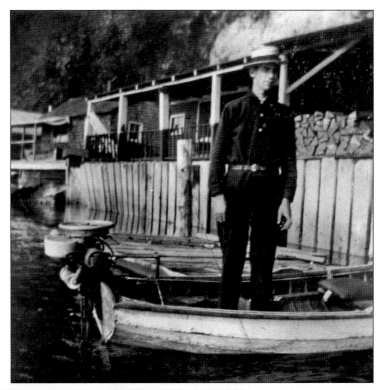

Little Archie, Willard, Earl, Lloyd "Bob," and Colonel "Jack" Coen, pictured here, are a small part of a huge Coen family. At the age of 16, Mabel Coen married a 50-year-old widowed minister with nine children and together they had seven more children. But their camp was burned on June 29, 1925, when a moonshiner's still exploded. (Courtesy of Hazel and Beulah Carr.)

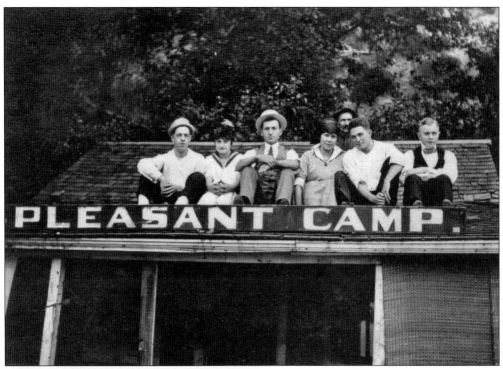

Just south of the general store was Pleasant Camp, which was rented to a group of girls from Stadium High for the summer of 1914. Pictured, from left to right, are Horace Adams, Helen Hartman, Louis Willison, Alice Swift, Ercil Bennatts, and another boy. Jens Nilsen, the manager of the boathouse, is behind them. Alice married Ercil, who later sold cars for Titus Motors Company. (Courtesy of Ercil Bennatts.)

Herbert Hager, son of Abner and Drusie Hager, watches his parent's cabin. Two Hager brothers, Ab and Bill, both lived at Salmon Beach before World War I. Ab built boats and Bill worked for Foss Launch and Tug Company. Note the tent frames at left. (Courtesy of Ercil Bennatts.)

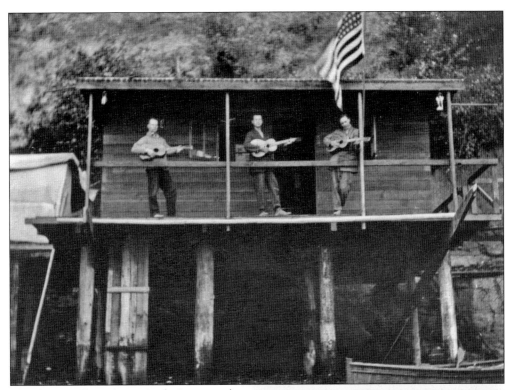

The three Willison boys, Andy, Louis, and
Herb, entertain the girls from the porch of
their parent's camp north of the boathouse,
which is in the vicinity of No. 16 now.
(Courtesy of Ercil Bennatts.)

Standing on the gangway leading to the
floating boathouse, Ellen Olson and Elsie
Nelson enjoy the boy's attention. At left
is the stairway to an apartment used by
the boathouse manager's family. The large
building at right was used for boat storage in
the winter and a dance hall in the summer
until Charles Ziegler started the Salmon
Beach General Store. (Courtesy of
Ercil Bennatts.)

Vivian Korjan and Ellen Olson rest in front of the Foss Boathouse, which was built in 1891 and towed to the Narrows in 1906. Note the comfortable apartment upstairs and small shack on the trail above it. (Courtesy of Ellen Olson Allie.)

Ernest Lusha does his best balancing act by standing on his head in a rowboat. (Courtesy of Pearl Lusha Young.)

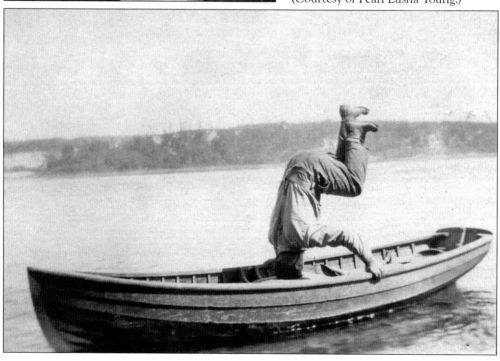

Jennie Lusha tells her husband to get back to work cleaning the fish. (Courtesy of Pearl Lusha Young.)

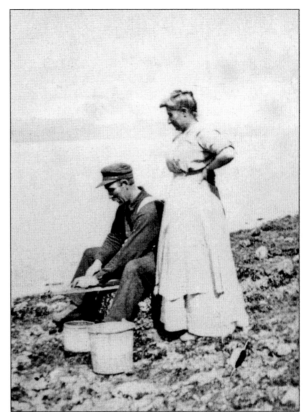

Ernest and Maude Lusha bought Camp Soo for $100 in 1918. Maude's sister Mae and her husband, Jessie Williams, also had a camp nearby. Both camps were destroyed in 1919. Their uncles Nate and Bert Jessmer owned a camp that survived the slides, which is now No. 20. (Courtesy of Pearl Lusha Young.)

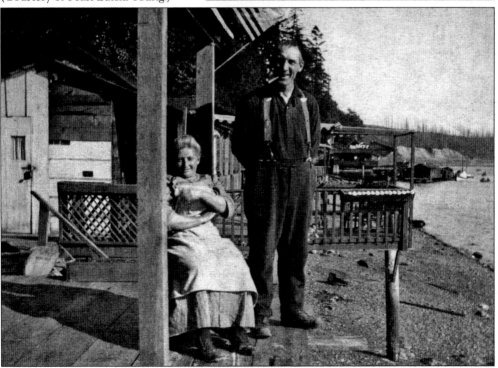

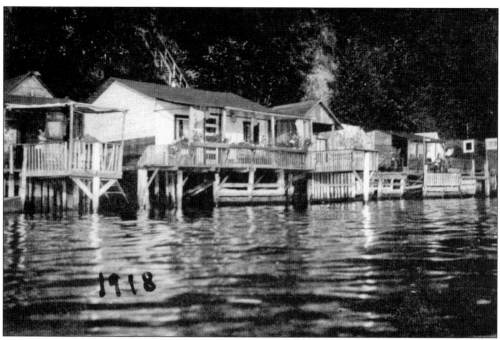

Louis Anderson built this large white cabin, now No. 7, behind a spring. His daughter Thelma was born on the beach in November 1918. They then moved to Ruston after the slide of January 1919. (Courtesy of Thelma Anderson Conger.)

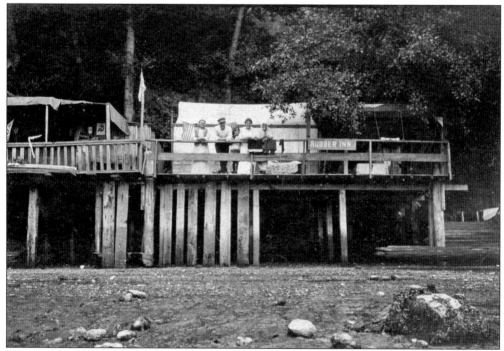

Before numbered addresses, even the most humble camp had a name, such as Rubber Inn. Camp signs were often nailed to a railing. At left, Bob White Camp is visible. (Courtesy of Hazel and Beulah Carr.)

Next to the Rubber Inn was Bob White Camp, built by Mason Jones in 1907, which is now No. 3. (Courtesy of K. Florine Mason Hendrickson.)

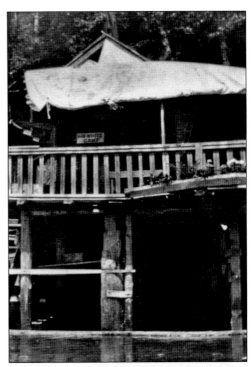

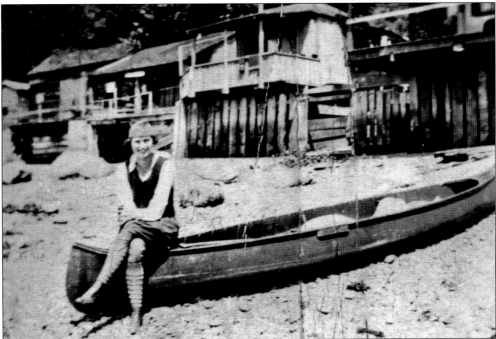

Ray and Frances Mooberry had two athletic children, Gretta and Jack. Gretta sits here on her rowing canoe; she later married Bill Hager. Her younger brother Jack coached the Washington State University Cougars track team for 28 years. While there, he coached 53 All-Americans, a dozen NCAA champions, and more than half a dozen Olympians from three countries, and was named Track Coach of the Year in 1973. (Courtesy of Billie Jean Hager Hagenau.)

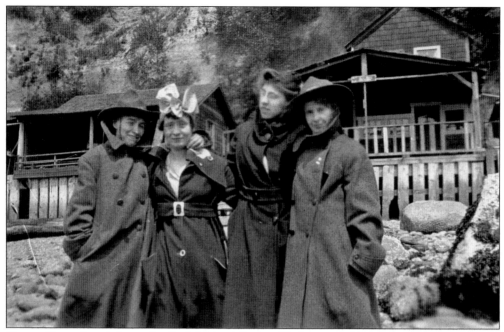

Pictured here, from left to right, Frida Nelsen, Francis Underwood, Olive Bokien, and Hazel Carr show off the latest wear—Army overcoats and hats—on a cold day in May 1918 in front of Camp Wanaton, which is now No. 43. (Courtesy of Hazel and Beulah Carr.)

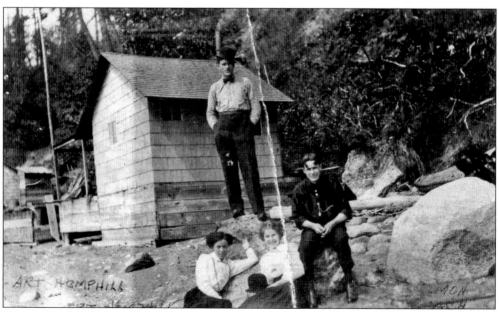

Art and Bert Hemphill pose in their Sunday best with their sweethearts at Camp Red Wing near the tunnel around 1910. (Courtesy of Art and Bobbie Hemphill.)

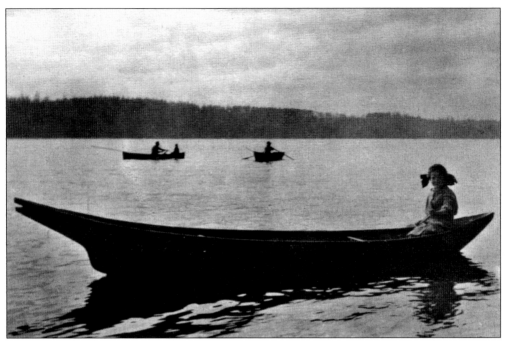

Beulah Shaw paddles around in an old Native American dugout canoe, which has been carefully preserved by her daughter, a history teacher on Vashon Island. (Courtesy of Nancy Reed Mish.)

Howard and Ina Shaw built Camp Dixie in 1915. A spring above the clay bank provides fresh water, and still does today behind No. 37. On the south side was Camp Oneida, which George and Calla Byrne renamed Camp Vernita for their daughter. George was a printer for the *Tacoma Tribune*. (Courtesy of Nancy Reed Mish.)

Jessie and Lillie Poyns enjoyed summers at Camp Little Rock between 1913 and 1919, now No. 82. Note that terracotta sewer pipe, which cracks easily, should not be used as stovepipe material, especially since Jesse was an employee of the Tacoma Fire Department. (Courtesy of Donald Bushaw.)

Hannah Bartlett is a happy camper in front of Camp Kinni-Kinic, now No. 99. On the south side was the Cliff House. (Courtesy of Minnie Bartlett Lytle.)

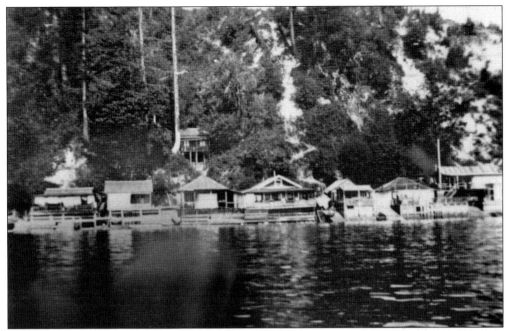

Access down to these camps was by a switchback trail, known as the Bright Angel Trail after a similar one in the Grand Canyon. Adolph Gertig, who worked on the Nelson Bennett tunnel at $2 per 10-hour day, owned the shack in the ravine. His cabin slid down on top of the cabin below it in 1919. (Courtesy of Adolph Gertig.)

Foss's rowboat-rental business was booming. In 1913, you could buy a 12-foot skiff from Crawford Boatbuilding in Gig Harbor, without fixtures or oars but including one coat of paint, for $1 per foot. Oars cost 7¢ per foot, and leather for oars sold for 50¢ as a readymade kit. (Courtesy of Ercil Bennatts.)

Wood stoves for cooking and heating required lots of firewood. If fishing was poor, a log was tied to the boat and rowed home with the tide. As Art Lillyroot demonstrates, the real work begins by cutting the log into stove-size pieces with a "misery whip." (Courtesy of Art and Bobbie Hemphill.)

With Paul Newman at the oars, the young women entertain themselves with a ukulele and a portable Victrola phonograph. Paul Newman later became Pierce County treasurer. (Courtesy of Minnie Bartlett Lytle.)

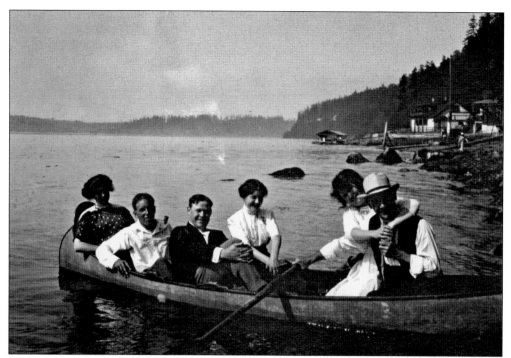

The *Belle*, an elegant Peterborough rowing canoe, carries, from left to right, Ruth Walters, Heimie Wendt, Ray Dungan, Margaret Dungan, Etta Wendt, and Walter Eudey. In the distance is Point Defiance, a 630-acre park and former military reservation. (Courtesy of Ceta Wendt Condon.)

Joe Starr proudly wears his World War I sailor's uniform on a visit to see his cousin Art Hemphill. Joe also built a cabin near the tunnel, now No. 103. (Courtesy of Art and Bobbie Hemphill.)

Fred Bartlett (right) and two buddies stand at attention for the photographer in front of Cliff House, now No. 100. The boy at left appears embarrassed to wear new overalls with rolled-up pant legs, which his parents expected him to "grow into." (Courtesy of Minnie Bartlett Lytle.)

These Stadium High girls practice gymnastics in front of the Bennatts's camp. A new cabin pictured in the next photograph has replaced the tent at right. (Courtesy of Ercil and Alice Bennatts.)

34

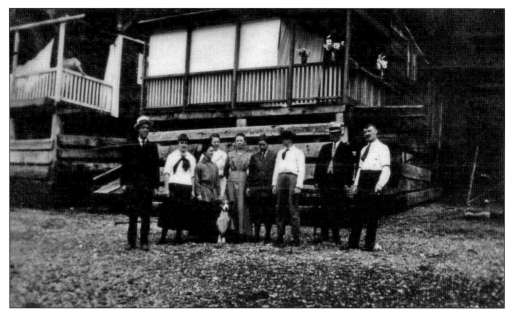

In 1915, Frank Carrier built a new camp, replacing the tent platform in the previous photograph. Pictured here, from left to right, are Frank Carrier, Inez Hall, Clyde Miller's mother Mrs. Frank Carrier, three other visitors, and Walter Staples (Courtesy of Ercil and Alice Bennatts.)

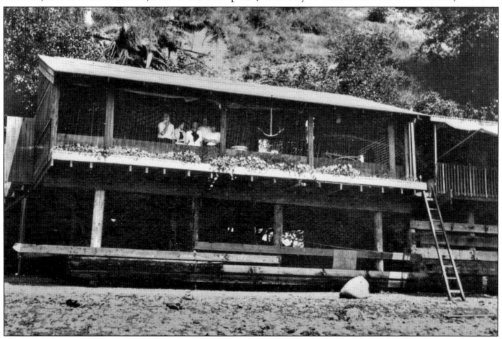

Ercil Bennatts and Ray Converse built this camp together, as shared ownerships were common. Johnny Underwood and Bert Ohiser shared a cabin, as did Emil Tietje, Billie Crain, and Bill Muehlenbruch with theirs near the store. Guy Mundum, George Sager, Charles Anderson, and Charlie Ryan named their camp Unity Club, which is now No. 19. Four waiters from the Tacoma Hotel appropriately named their cabin "White Caps," now No. 18. (Courtesy of Ercil and Alice Bennatts, and Bonita Turner Ohiser.)

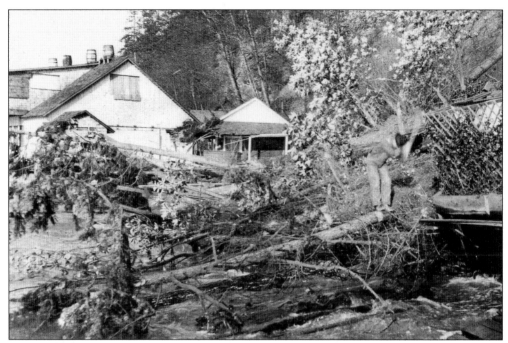

Howard Shaw chops the trunk of a fallen tree after a slide between Pleasant Camp and Camp Dixie. Slides never stopped construction of beach cabins at the foot of steep slopes in those days. "Build at your own risk" was the rule, for neither the landowner nor the government was responsible for safety, unlike today's legalistic concern over liability. (Courtesy of Nancy Reed Mish.)

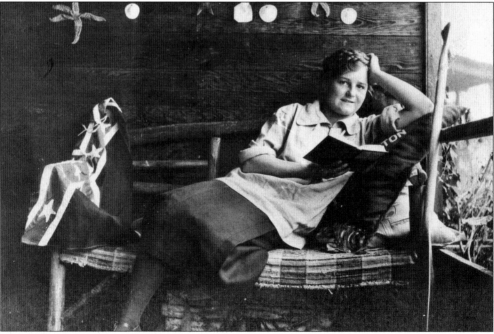

Ina Shaw reads a book at Camp Dixie. The Stars and Bars flag of the Confederacy is proudly displayed, and starfish and clamshells decorate the wall. Underneath the couch are life preservers made from canvas-covered blocks of cork. (Courtesy of Nancy Reed Mish.)

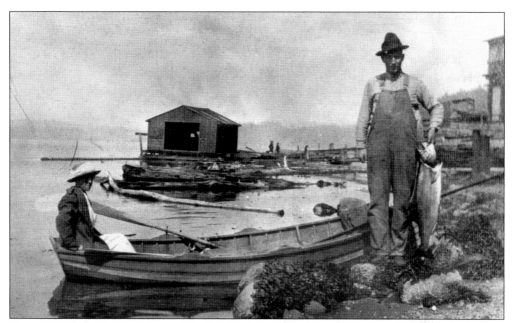

Howard Shaw holds up a salmon. The floating logs trapped along this side of the boat shed should be explained. On the east side of the Narrows, a strong current flows north toward Point Defiance. When the tide is incoming or southbound, the northbound current along the east shore is called a back eddy (water moving backward against the main flow) and smart fisherman could make a loop in the Narrows without rowing against the current. (Courtesy of Nancy Reed Mish.)

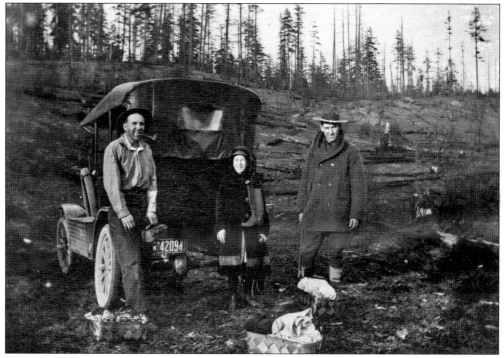

Heimie Wendt and his daughter Ceta park their Model T at the top of the bluff in 1918. Accompanied by an uncle, they take a picnic lunch to Flapjack Lodge. (Courtesy of Ceta Wendt Condon.)

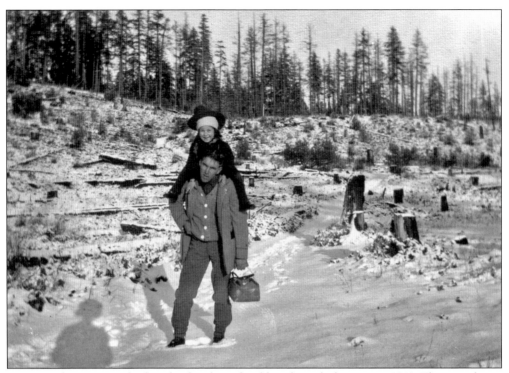

Ceta Wendt gets a piggyback on her brother's shoulders through the snow in 1918. The row of trees in the background marks the southern boundary of Point Defiance Park. The Baker property above Salmon Beach was bare, except for a few stumps. The Douglas fir and hemlock had been logged before 1900, and the remaining trees were sold as fuel by Dan McGeady to Ruston homeowners. (Courtesy of Ceta Wendt Condon.)

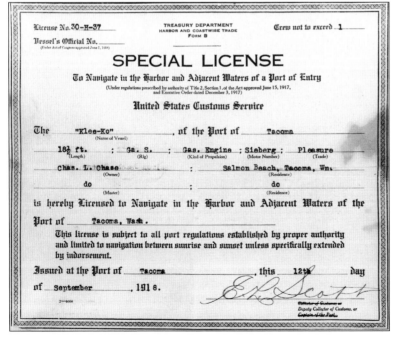

During World War I, gas-powered boats required a special license from the United States Customs Service. Charles Chase named his vessel *Klee-Ko* after a cabin by the same name. This license limited navigation between sunrise and sunset, which made rumrunning at night more difficult during Prohibition. (Courtesy of Charles Chase.)

Camps like Beach Nest were sold with a simple bill of sale. Charles Chase was a machinist and later Tacoma's first motorcycle policeman. According to a newspaper interview in 1954, he was the unofficial mayor of Salmon Beach. After the store closed in 1956, he stored all mail for beach residents in apple crates on his front porch until his death in 1962. (Courtesy of Charles Chase.)

BILL OF SALE OF CAMP "BEACH NEST" ON POINT DEFIANCE NARROWS.
This day March 26th, 1915

Received of Chas. L. Chase $90.00 to apply on above named camp, agreed selling price $100.00 one hundred dollars, balance to be paid within next six weeks, or not not later than May 16th, 1915, which said balance is $10.00 This bills of sale covers house, Shed, and all contained therein or around that belongs to the house.

I the owner, relinquish all rights to said house, Shed and all contained therein or around that belongs to the house (This does not include the land upon which the house and shed stand) upon full receipt of payment of one hundred dollars($100.00)

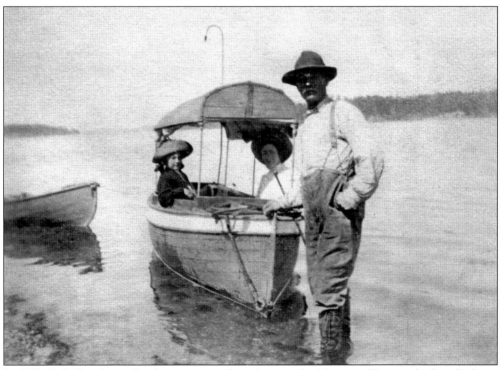

In 1910, J. C. Foord was the first year-round resident on the Narrows. He even had a telephone (Main 8564) before the Proctor exchange existed. But he was unhappy. Too many camps were crowded together because of recent railroad construction on the Narrows. So he packed his wife and daughter into his 20-foot boat, the *Dub*, and off they went to Alaska. (Courtesy of Esther Foord Miller.)

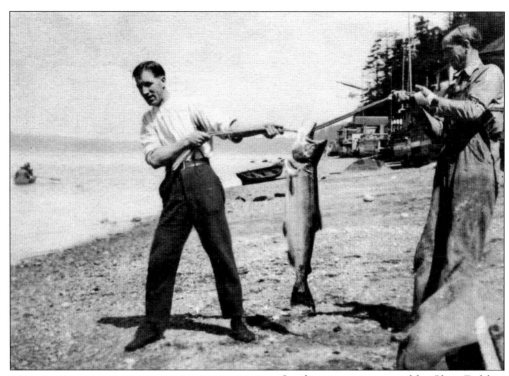

It takes two strong men like Chris Dahl
(left) and Art Lilliroot (right) to hold up
this salmon. Mike Marush, of Old Town,
sold salmon like this at the Crystal Palace
Public Market for 7¢ per pound from
1910 to 1915. Octopus was sold mostly to
Japanese for only 4¢ per pound. (Courtesy
of Art and Bobbie Hemphill.)

Behind Anna Farrell, in her sailor outfit,
are many layers of impervious stratum,
commonly called a clay bank. Above the
clay is glacial till where hand-augered
holes provide spring water. Geologists
identified one clay layer as ash from the
ancient eruption of Mount Mazama. Large
rocks or boulders on the beach provide
mute evidence of mudslides where the clay
and gravel have washed away. (Courtesy
of Hazel and Beulah Carr.)

Three daughters and the wife of another shipyard worker, Otto Ellison, gathered on the beach in 1919. Pictured, from left to right, are Burnett, Lillian, Mom Ellison, and Willamina or "Wally" Ellison. Otto's wife's real name was changed from Walburga to Mollie, which was common practice for many recent German immigrants. The cabins behind them were often just one room with a large deck. (Courtesy of Lillian Ellison Johnson.)

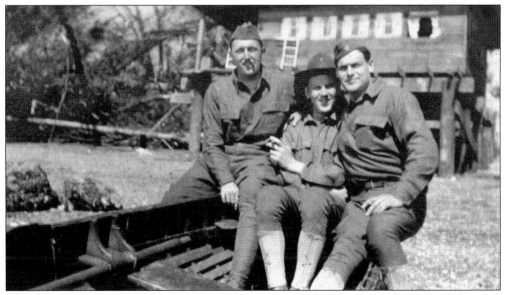

The Ellison girls invited the boys from Camp Lewis to join them at the beach. Pictured, from left to right, are Louie Jacobson, Adolph "Ad" Johnson, and Ralph Swanson. Lillian "Lilly" became Mrs. Johnson. Disregarding the fallen trees and debris at the foot of the cliff, a new cabin is being constructed during the summer of 1919. (Courtesy of Lillian Ellison Johnson.)

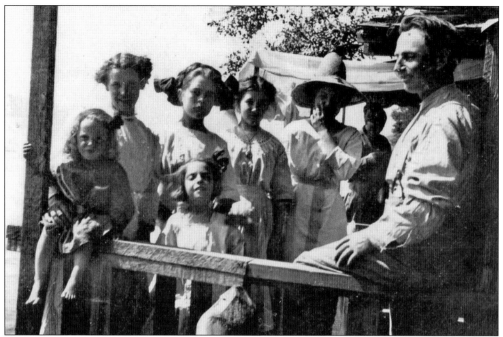

Mason Jones built Bob White Camp near the clay banks in 1907. At the railing are his children, Florine and General. In the back row, Mae, Pearl, Gladys Petry, and Georgia are all eligible, attractive young women. Andrew and Thea Foss stayed at the beach one summer and Florine taught Thea tatting. (Courtesy of K. Florine Mason Hendrickson.)

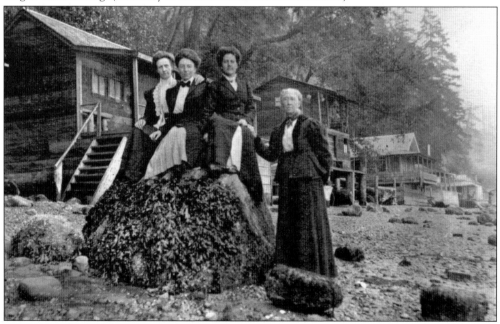

Eva Pitts and three lady friends pose in elegant Sunday attire. Eva is a grandmother of Richard Turner, who has owned several cabins at Salmon Beach since 1961. Richard explains that relatives on both sides of his family were ministers, so that may explain the solemn expressions on these women's faces. (Courtesy of Richard Turner.)

Two

CHEAP RENT, FISHING, AND MOONSHINE

1919–1933

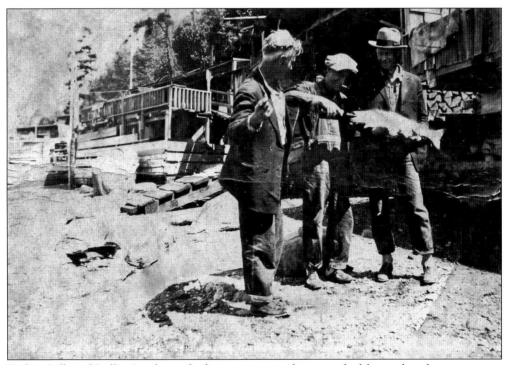

Walter, Bill, and Rollie Crooks try feeding some moonshine to a freshly caught salmon—instant marinade. Bill Crooks, an expert shingle weaver, and his daughter Violet both owned cabins until the 1960s. None of the Crooks had much ambition, except Rollie, who bought a failing rug-reweaving business. Rollie loved to sing "The Cat Came Back" while fishing. For his funeral in 1940, Mellinger Funeral Home made a canoe out of daffodils. (Courtesy of Violet Crooks Trask.)

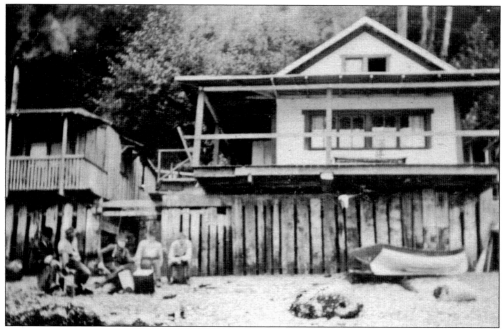

The Mooberry's old cabin, now No. 53, was sold to a bootlegger Ed Stickney. On December 30, 1925, dry squad officers raided the big white house and took four copper stills, moonshine of high grade, blackberry cordial, beer, and mash. Stickney was arrested and posted $500 bail. Most of the liquor was to be shipped to Olympia for sale while the state legislature was in session. (Courtesy of Billie Jean Hager Hagenau and the *Tacoma Times*.)

In 1923, Frank Keizer, Mildred Sweet, Frances Ohiser, and Frank Rogers look dressed up for a dance. Brush begins to grow on the hillside behind the first garage in the parking lot above Salmon Beach. (Courtesy of Bonita Turner Ohiser.)

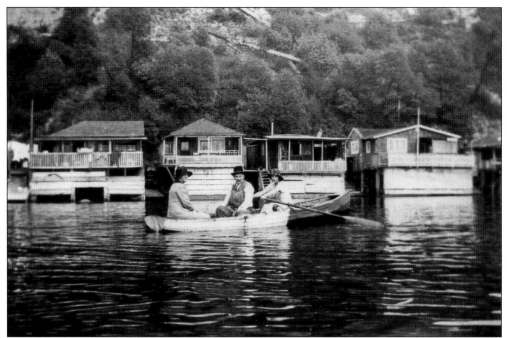

In 1924, Nicholas and Anna Trompen's daughter Grace rowed some guests from Nebraska in their half-painted boat past today's Nos. 101 through 104. Their camp had the flat roof, next to Kloeppers at far right. (Courtesy of Grace Trompen Johnson.)

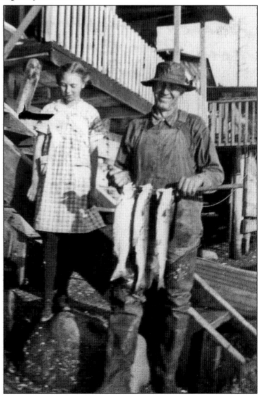

In 1922, Nicholas Trompen holds three fine salmon while his daughter Grace looks on. (Courtesy of Grace Trompen Johnson.)

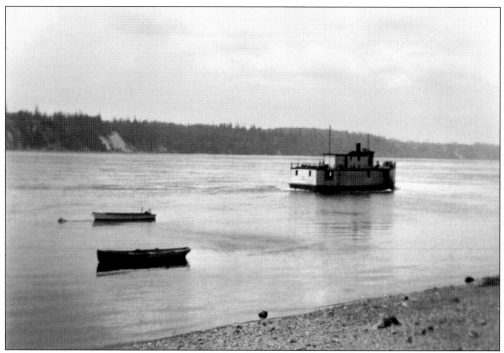

In the 1920s and 1930s, beach campers watched dozens of nondescript freight boats like this one that hauled livestock, produce, and berries from the Kitsap Peninsula to markets in Tacoma and Seattle. (Courtesy of Florence Sackett.)

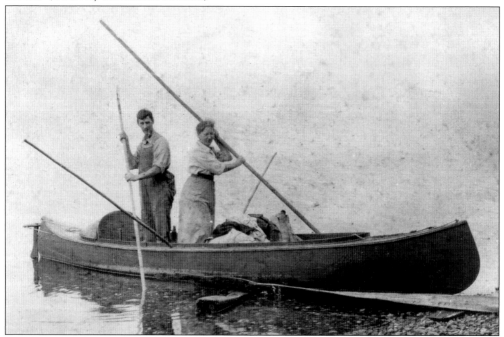

An ideal watercraft for beach camping would be this rowing canoe with a rudder controlled by wires. Two adults, a pile of heavy clothes, and other provisions stowed in the bow could navigate the strong tides and currents through the Narrows. (Courtesy of Nancy Reed Mish.)

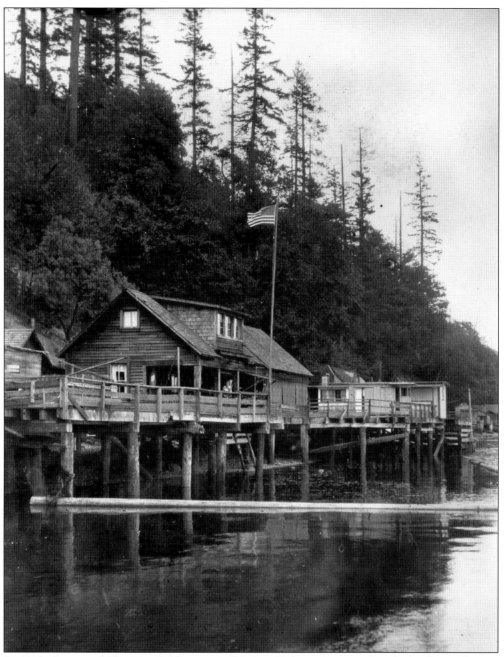

In 1925, Oscar and Florence Sackett rented Camp Waltonia, pictured with the flag. Adjacent camps in the distance are Lucky Strike and the Boxcar, all rental cabins on Foss tidelands south of the store. All traces of these camps have disappeared, except Lucky Strike's square timbers, which support No. 36. Wooden storm shutters hinged at the top protect open porches during the winter or when unoccupied. (Courtesy of Florence Sackett.)

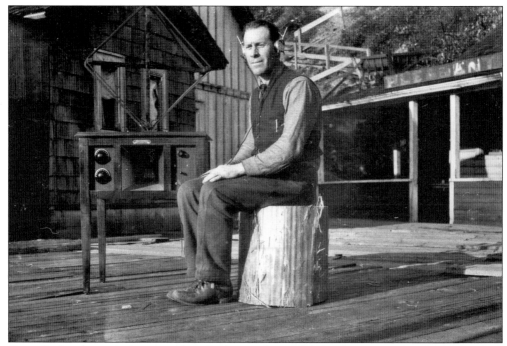

Oscar Sackett listens to his new radio, which was advanced technology in 1925. In the background is the south side of the store, and the Pleasant Camp sign is fading fast. Behind the radio is a small shed that contained a large sea turtle pickled in formaldehyde. (Courtesy of Florence Sackett.)

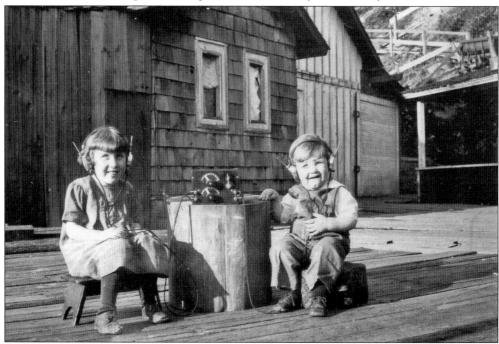

The Sackett's children, Edna and Richard, were fascinated by radio, too. A small wireless crystal set had no speakers, so a $20 headset by C. Brandes of New York was a child's dream come true. (Courtesy of Florence Sackett.)

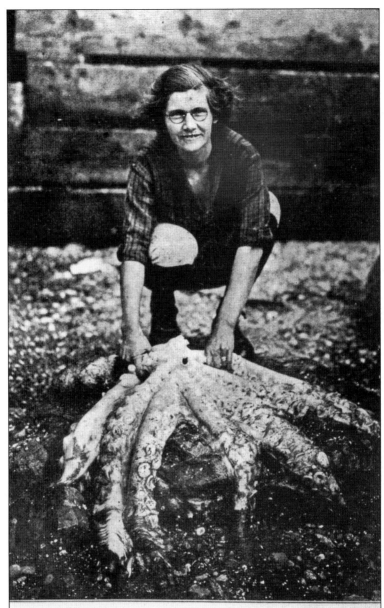

This sort of thing is all in the day's work for Mrs. Luvina Hause. She is dragging a forty-eight pound octopus from her boat to a box on the beach. Although badly gaffed there was some life left in the devil-fish and she was obliged to turn it over on its back to prevent the suckers on its tentacles from fastening to the rocks in its path

An article on interesting Westerners in the February 1924 issue of *Sunset Magazine* was this community's first publicity in such a publication. Lavina Hause gaffs a devilfish, otherwise known as an octopus, the writer states. Chinese and Japanese used octopus in chop suey, but it had to be skinned and pounded to make tender. Greeks used octopus in salads. Lavina learned how to catch octopus from "Devilfish" Pete Vlastelica, a former opera singer, whose booming voice could be heard the full length of the beach. The author found Lavina in 1975, then called Lavina Hause Nordstrom, and convinced her to do an interview with Joe Larin, editor of the *Eatonville Dispatch*. (Courtesy of Tacoma Public Library.)

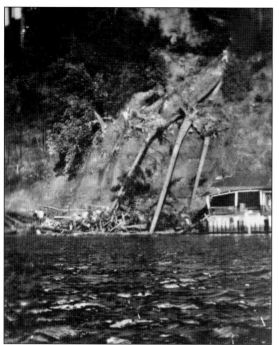

Where Nos. 40 and 42 are today, three camps were destroyed when heavy rainfall turned steep slopes to mud and alders and firs started sliding. The worst mudslide known was on January 23, 1919, when 14 camps were lost. Mudslides have also occurred in December 1933, February 1951, February 1972, and February 1996. When rain exceeds three inches in 36 hours, old-timers say to grab your socks and leave. (Courtesy of Art Hemphill.)

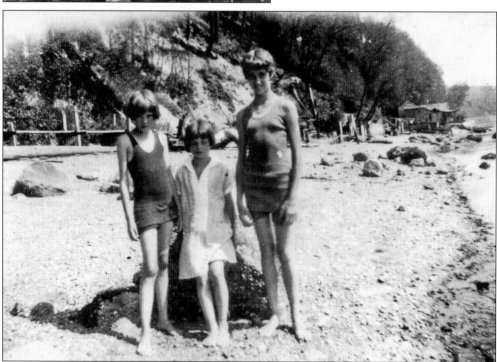

On June 29, 1925, four cabins (behind these girls) burned, where Nos. 43 to 48 are today, when a moonshiner's still exploded. Other major fires occurred in December 1948, February 1953, and July 1969. Careless or intoxicated smokers were often at fault. After waiting helplessly for 45 minutes for the fireboat, Big Bertha's powerful pumps plastered the hillside with the charred cabin's remains. (Courtesy of Lois Sanderson Lutes.)

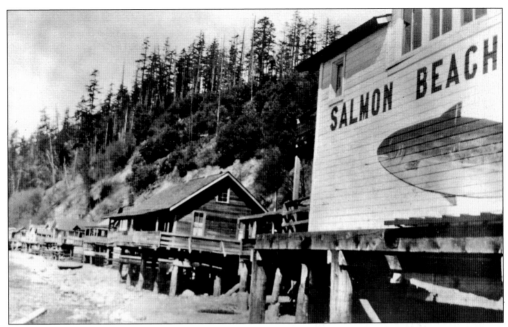

A new boatshed and workshop was built in 1922, squarely in front of A. J. Cournau's Camp Melrose and north of the original Foss Boathouse. Another Foss rental was the Bone Dry, a duplex, towed from the developing Port of Tacoma. Andrew Foss was frugal, according to his son Henry and others remember him even saving bent nails. Gradually, all the rentals disappeared for lack of maintenance. (Courtesy of Albert Anderson.)

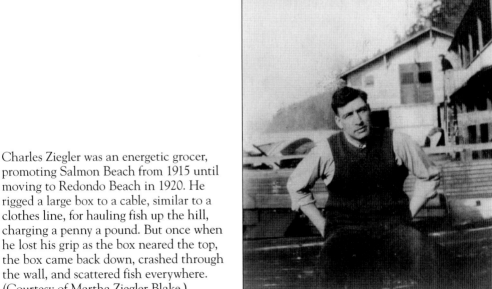

Charles Ziegler was an energetic grocer, promoting Salmon Beach from 1915 until moving to Redondo Beach in 1920. He rigged a large box to a cable, similar to a clothes line, for hauling fish up the hill, charging a penny a pound. But once when he lost his grip as the box neared the top, the box came back down, crashed through the wall, and scattered fish everywhere. (Courtesy of Martha Ziegler Blake.)

Alva Musser was a devout Dunkard, a branch of the Church of the Brethren. He worked a double shift at the Ruston smelter during World War I until he had enough money saved to buy out Ziegler's Store in 1922. He sold lots of sugar, unaware that it was used to make moonshine. He died behind the store counter in 1924. (Courtesy of Margaret Francy.)

Pictured here, from left to right, are youngsters Walter Blomberg, Dale Isley, Albert Anderson, Kenneth Isley, Carl Anderson, and Harold Mize, seated next to Max Anderson, the boathouse manager from 1926 to 1930. Foss numbered the clinker-built rental boats, with vessels over 100 being double-oared and those under 100 as single-oared. The *Viking* was double-ended. The *Hope* had history "a mile long" according to Henry Foss and was for outboard motors only. (Courtesy of Claude and Lena Isley.)

Warren "Buddy" Hager (left) and Herbert Hager look miniature next to this salmon. (Courtesy of Billie Jean Hagernau.)

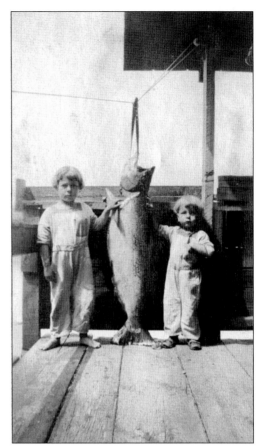

To create more space to tie up rental rowboats, Foss installed a row of dolphins, a cluster of three pilings tied with cable on top. At the north end, "Dirty Neck" Bill Anderson lived aboard the *Mud Scow*, seen over the shoulder of an unidentified cub scout. (Courtesy of Billie Jean Hagernau.)

Pictured, from left to right, are photographer Marcus Zausmer, alto soloist Birdien Kloepper, and composer/pianist Bernard Wagness. All are from the College of Puget Sound (CPS), now University of Puget Sound (UPS), in Tacoma. Birdien's elegant parasol and the men's knickers would certainly stand out among the fishermen near the tunnel in 1923. Her husband, Frederick Kloepper, was a music professor at CPS. (Courtesy of Birdien Kloepper.)

An attractive secretary at CPS, Olive Brown visited the Sprengers near the Doohan's cabin in 1921. Her married name, LeSourd, is significant because one of the founders of CPS was Dr. David LeSourd, a minister of the Methodist Episcopal Church in Tacoma's North End. In later years, UPS Professor John Magee, C. Brewster Coulter, Anne Wood, Al Eggers, Stuart Smithers, and Tom Rowland all owned cabins. (Courtesy of Birdien Kloepper.)

Mrs. Harry Egan and Mrs. Jimmie Doohan wear more appropriate attire for the beach. Actually, wool bathing suits are much warmer than synthetic fabrics of today. The author collects wool bathing suits in beautiful colors, made mostly in Portland by Jantzen, Web Foot, and Lyman Wolfe. (Courtesy of Kathleen Doohan Kizer.)

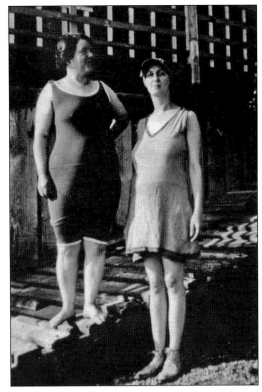

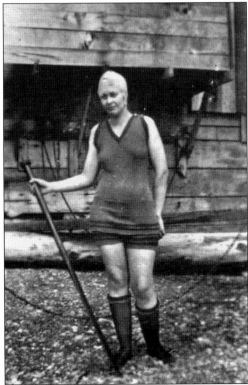

Mildred Doohan models her wool bathing suit, now complete with stockings, in front of their neighbor's camp, today's No. 72. (Courtesy of Kathleen Doohan Kizer.)

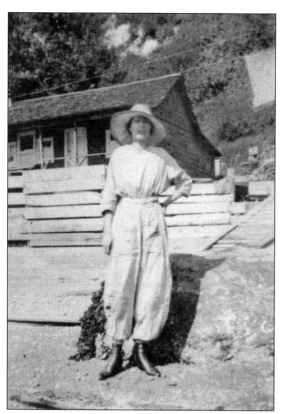

Mildred Doohan models her latest 1920s summer suit in front of her neighbor's camp, now No. 74. Her husband, Jimmie Doohan, was an expert mechanic and operated a garage at Division and I Streets. (Courtesy of Kathleen Doohan Kizer.)

Ludwig "Louis" Wieme stands on his porch as Camp Defiance is being moved forward after the disastrous 1919 mudslides. Note the end of a log sticking out at the lower right, which rolls at a right angle between the upper and lower row of square beams. Many cabins are moved away from the steep bank to lessen the danger from mudslides. (Courtesy of Fred Wieme.)

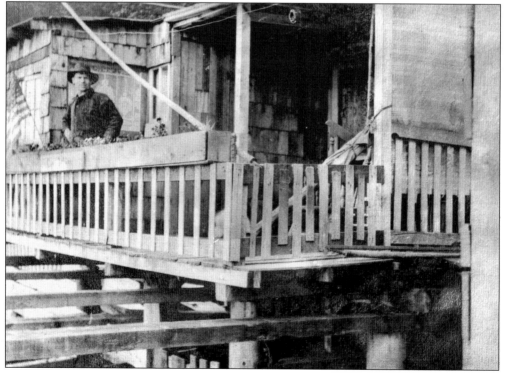

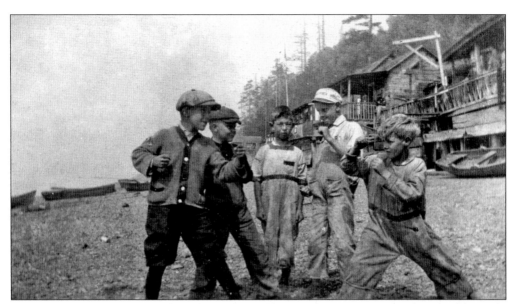

In 1918, Fred Bartlett and Charlie Tobin square off for some boxing practice as their friends watch. Every kid envied Marty Foley and Freddy Steele, boxing heroes from Ruston. During World War I, a severe housing shortage forced Todd shipyard workers and their families to live in summer beach cabins year-round. City directories show that residents more than doubled between 1918 and 1919. (Courtesy of Minnie Bartlett Lytle.)

Frank and Jessie McCandless pose with a fresh salmon, held by a gaff hook. Gaff hooks, herring rakes, and leather rubstraps used to be common fishing equipment. A "rub strap" is a strip of leather about 10 feet long, which loops around a fisherman's wrist at one end. The leather rubs back and forth across the stern, which jerks the fish line while rowing. (Courtesy of Birdien Kloepper.)

Jimmie Doohan, with wife and daughter, proudly shows off his new Lockwood Ace, a seven-horsepower rowboat motor. Fishermen, whose only source of income was fishing, could not afford a fancy motor on their rowboat. Summer-timers like the Doohans, Eatons, and Sprengers were called the "idle rich." (Courtesy of Kathleen Doohan Kizer.)

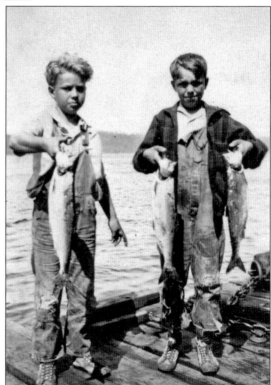

Dale and Kenneth Isley caught these fish on their first trip of the year in 1930. (Courtesy of Claude Isley.)

Leo and Carmie Booth, Charles and Dora Booth's children, had vivid memories in 1920 of burning logs rolling down the hillside behind their parent's camp near the tunnel. Beach cabins were simply all some families could afford. After two of Ida Wilcox's children died from salmonella due to improperly canned salmon, the family moved back to Montana. (Courtesy of Leo Booth.)

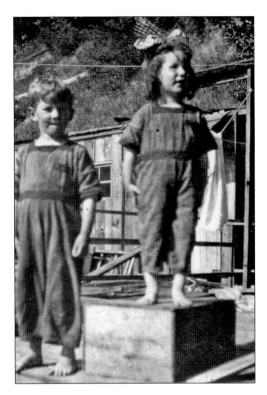

Grandma Ida Wardle rented Charles Chase's cabin for several years while he operated a trout farm. The woman on the left is one of her nine children. Before Ida married Sam Wardle, she was married three times and had three children by each husband. Perhaps that's why she made the best home brew on the beach. (Courtesy of Clarence Gunstone.)

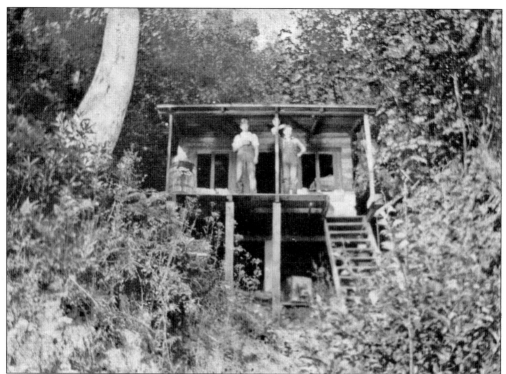

Adolph Gertig built three fishing shacks. The first one was destroyed by railroad construction. He constructed the second cabin in the gulch behind Nos. 64 and 65. The props that supported it were knocked out by the mudslide of 1919, and the whole cabin slid down the gulch, knocking the cabin below it onto the beach. (Courtesy of Adolph Gertig.)

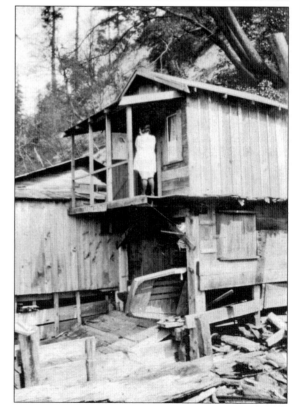

Adolph Gertig relocated his third cabin to the beach. Since space was limited, he built a narrow cabin on top of his boatslip, at the south end of No. 64. The woman on the porch is unknown. (Courtesy of Adolph Gertig.)

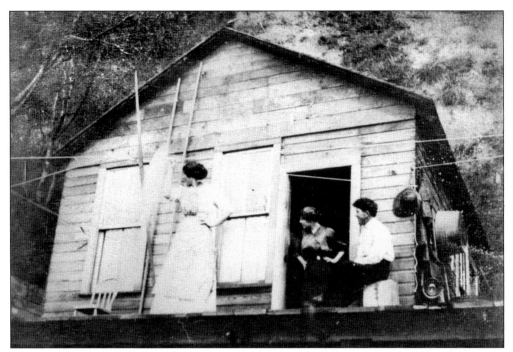

Ester Edwards and Art and Madge Allie watch the excitement from Bill and Nellie Allie's camp, now No. 69. The necessities of beach-camp life are a laundry tub, a clothesline, and herring rakes. Optional accessories include a fireman's hat belonging to Clyde Jenkins, a battalion chief of the Tacoma Fire Department. (Courtesy of Ellen Olson Allie.)

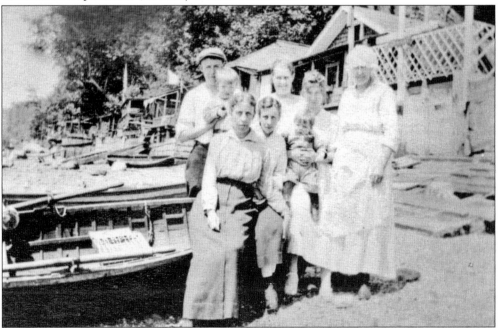

Looking north from No. 69, Melvin Allie holds the baby on the left. Bill's maternal grandmother, Cordellia Jenkins, stands at right, and between them are a multitude of Allie girls: Edith, Ester, and Muriel. (Courtesy of Ellen Olson Allie.)

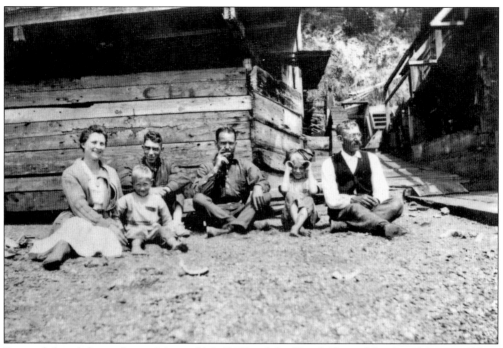

Pictured, from left to right, are Mrs. and Mr. Ed Havel, Joe Havel, Vivian Havel, and George Abling (wearing a vest). Abling was an educated man and subscribed to free government publications. He had been a railroad engineer, but lost his job because of a train wreck. (Courtesy of Isabel Havel.)

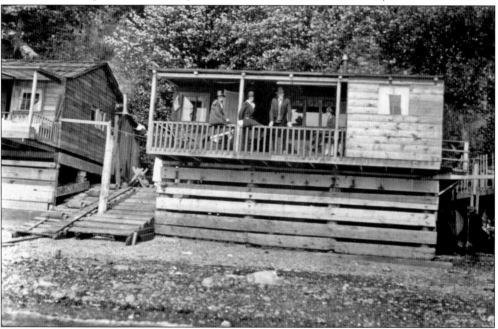

In 1920, Oscar and Florence Sackett stand in the center of the porch of their honeymoon cottage, the Springside Inn. The small room on the right side of the porch was the outhouse—there were no sewers until 1991. If some loose change fell through cracks between deck planks, no one would dare look for it until the tide came in. (Courtesy of Florence Sackett.)

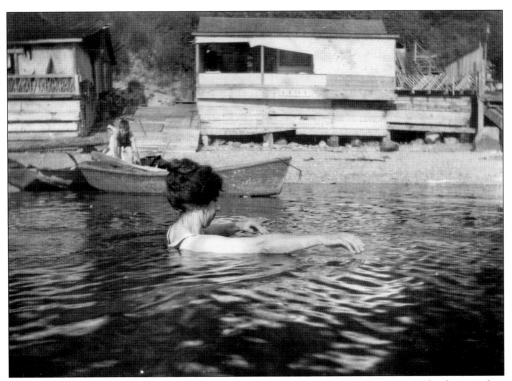

Evelyn Tobin swims in front of the Cliff House, now No. 100, in 1922. Her son Charley watches from the safety of their skiff. (Courtesy of Minnie Bartlett Lytle.)

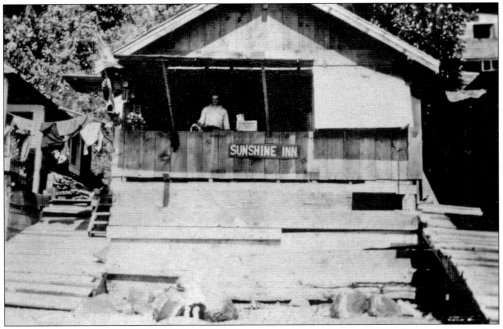

Sunshine Inn was a typical summer cabin with solid wooden shutters opened up on three sides. A little mudslide in 1923 pushed it over, but Herb Sprenger rebuilt it where No. 74 stands today. The Sprengers spent their summers here for 30 years. (Courtesy of Mrs. Herb Sprenger.)

Jimmie Doohan and Cliff "Dad" Steere are repairing the bottom of a boat tipped on its side. Behind the vessel, at left, is Sunshine Inn with the shutters closed down. This may explain the origin of the expressions "open up" and "closed down." (Courtesy of Mrs. Herb Sprenger.)

Three unidentified men show their day's catch at the Foss Boathouse. The best-known fishing grounds were a shallow underwater plateau just north of Point Defiance. Fishermen talked quietly about other fishing holes, such as Telegraph Eddy, for bottom fish like lingcod. (Courtesy of Pearl Lusha Young.)

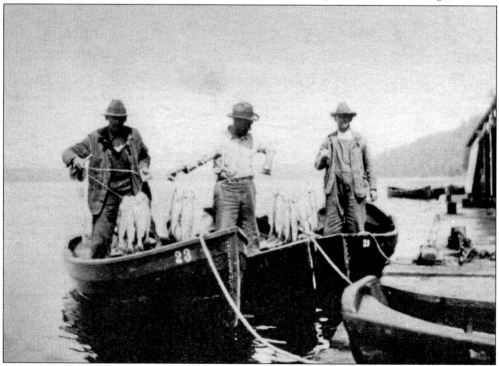

Three

FROM SHACKS TO CABINS WITH ELECTRICITY
1934–1948

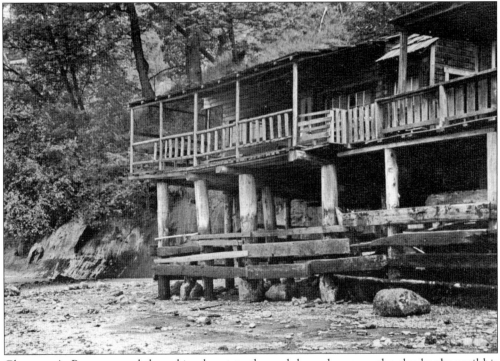

Clarence A. Potter owned the cabin closest to the park boundary near the clay banks until his death in 1965. He was chief of Battalion 2 at the end of his 40-year career as a Tacoma fireman. Unfortunately, his own cabin burned in the wee hours of December 8, 1934. Rebuilt as pictured in 1938, the cabin survives, although extensively remodeled by Joan Rutherford. (Courtesy of Barbara Stamey Nolen.)

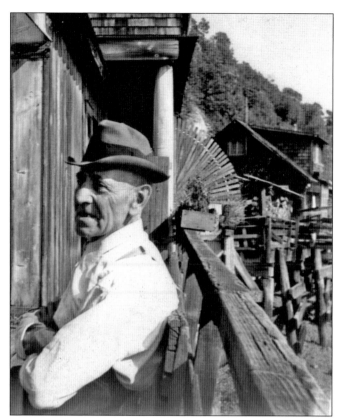

Louie Seyk rented the shack behind the Foss Boathouse and named it Camp Kewaunee, after his birthplace in Wisconsin. He bought candy for young girls like Nita Curtis, Dorothy Madsen, Charlotte Mims, Lucille Gilbo, Betty LaPlante, and Marjorie Leftwich. When drunks passed by on the boardwalk, he would hide the girls in front of the store. (Courtesy of Marjorie Leftwich Thorpe.)

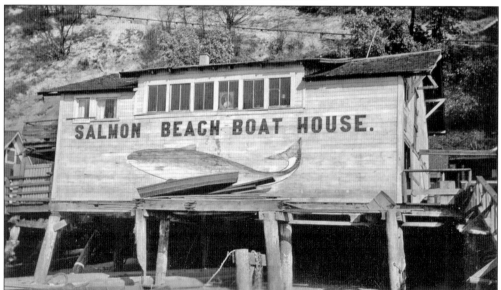

Electric lights had replaced kerosene lanterns in 1934 and families like Fuller, Thu, Thrall, Madsen, Mims, LaPlante, Murphy, and McCartney survived the Great Depression. The painted salmon looked faded here in 1937, the year Andrew Foss died. Upkeep on all rentals on Foss tidelands was negligible. After Gunnar and Elsie Blomberg sold the store in 1942, rumors spread that the beach would be wiped out. (Courtesy of Marjorie Leftwich Thorpe.)

Barry and Bertha Leftwich walk up the trail to the parking lot in 1940. Barry was a boxer, and in 141 fights with six-ounce gloves he was never knocked off his feet. He also played baseball at the catcher position. Barry described his weight as "three pounds under a horse" during an unforgettable interview at the Merkle Hotel on Pacific Avenue. He even made a homemade bandsaw at his cabin, now No. 20. (Courtesy of Marjorie Leftwich Thorpe.)

Gasoline was rationed during World War II, so cars left in the parking lot were easy targets for siphoning. At 1:00 a.m. on May 6, 1943, four cars in garages were burned. The author learned that a Salmon Beach girl suggested that her boyfriend "borrow" some gas so they could go to a dance. Inside the dark garage, the boyfriend lit a match . . . a big mistake. (Courtesy of Marjorie Leftwich Thorpe.)

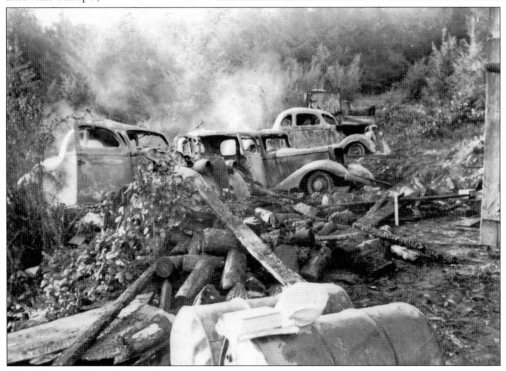

Charlotte Mims, the only child of Otto and Fern Mims, puts her arms around Gertrude and Erleen Niles. The Ruston kids stopped calling her "fish and potatoes" after Bert McCammon drove the Salmon Beach kids to Stadium High School in his dad's new 1938 Oldsmobile. Later during World War II, Charlotte was attacked by soldiers, but her father shot a couple of them, and spent a week in jail. (Courtesy of Marie Niles.)

Swimwear was changing during World War II. Cotton replaced itchy wool suits, but why should men need all that wet cloth above their waist? When Jantzen created two-piece swimsuits for women, made of elastic nylon material, men wondered why they couldn't wear just the bottom half. Joe Kowalchuk said, "If my neighbor Art Clow can do it, I can, too." Pete Miller, another neighbor, stands at left. (Courtesy of Dorothy Kowalchuk Scott.)

Federal officials considered building a suspension bridge across the Narrows the "bridge to nowhere", especially since there was ferry service from Sixth Avenue. Looking across the Narrows, only one porch light was visible at night from Salmon Beach. Who needs a bridge? But jobs were needed during the Depression, so two magnificent concrete towers, like this one, were built in 1939. (Courtesy of Barbara Stamey Nolen.)

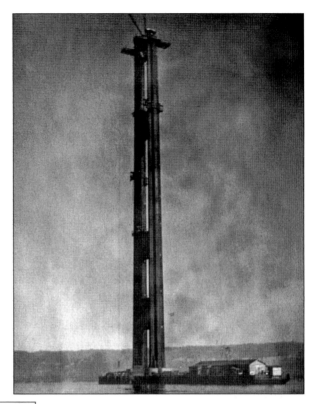

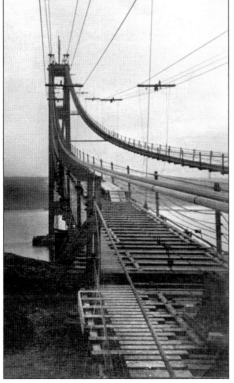

A suspension bridge is basically a cluster of cables spun in a graceful catenary curve between the towers and extended to anchorages at each end. A deck is then suspended from these cables. The highway engineers thought a two-lane roadway would be adequate for decades. The new bridge opened in the summer of 1940, and soon became known as "Galloping Gertie" because it twisted in the wind. (Courtesy of Barbara Stamey Nolen.)

Before bridge construction began, Roy LaPlante knew that Camp Waltonia was too small for his growing family and thought perhaps the new bridge could provide some building materials. First he bought some timbers from the Day Island mill and rounded up some creosote piling to use for posts. It took all the summer of 1938 to dig deep holes and set up piling posts for four rows of foundation timbers. (Courtesy of Royal LaPlante.)

Concrete was poured inside wooden forms, which were removed or "stripped" after the concrete hardened. This floating bonanza of lumber, coated with concrete, was collected in rafts and floated to Salmon Beach with the outgoing tide. Roy put his 10-year-old boy to work scrapping off concrete from the used shiplap, two-by-fours, and two-by-sixes. Today it is called recycling lumber. (Courtesy of Royal LaPlante.)

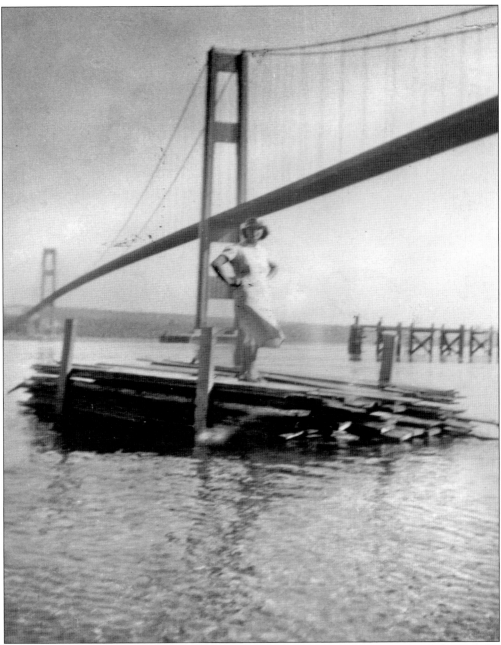

Margaret Louise Shannon LaPlante, queen of the raft, is towed by her husband, Roy, under the deck of the new Narrows Bridge in 1939. Margaret was a very beautiful and independent woman, who operated the Crescent Heights Grocery after moving to the top of McMurray Road in Northeast Tacoma. Her son, an author of several historical novels, has written a self-published autobiography about growing up on Salmon Beach between 1933 and 1948, titled *Salmon Beach—Sonny's Adventures*. After the earthquake in April 1949, Streich Brothers moved the LaPlante's new cabin onto a barge. The cabin still exists today in Edgewood, east of Tacoma. Ironically, Earl Rowe built another cabin on this site, No. 40, with reject lumber salvaged from his Loxide plant on Day Island in 1963. (Courtesy of Roy "Sonny" LaPlante.)

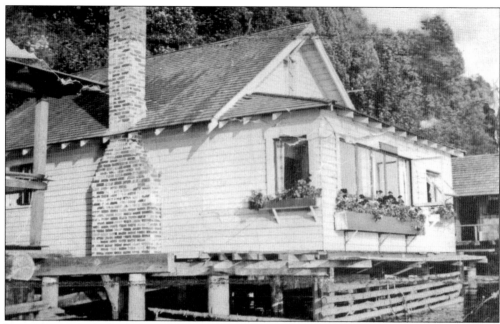

Lee and Marie Niles built this elegant cottage with a brick fireplace in 1934, where No. 54 is today. Lee, an electrician, strung "knob-and-tube" wiring through the attic, often to a single ceiling fixture in each room. Electricity was too expensive for anything but lighting, so wall outlets were unnecessary. Marie Niles talked John S. Baker into writing a legal trail easement from the parking lot to the beach. (Courtesy of Marie Niles.)

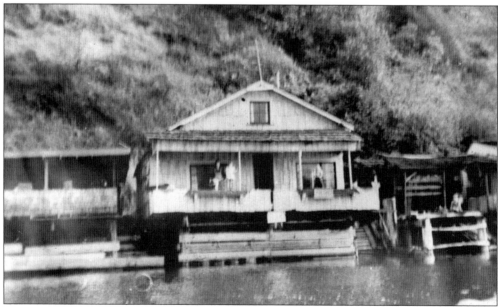

Elmer and Emma Crossman built this cottage using hand-split cedar shakes in 1934, where vacant lot No. 80 is today. One of their two beautiful daughters, Regine, went to Hollywood but died in an auto accident. Their first camp was between the cabins of two bachelors, George Abling and George Mills. They sold it in 1942 and moved to Titlow Beach. (Courtesy of George McDonald.)

Richard Beall saw an octopus near the shore while visiting his grandparents, Clarence and Ruth Baxter, during the summer of 1947. Neighbor Tom Nick told him to gaff it quickly before the tentacles could grip the rocks. Virna Haffer photographed his trophy with his friend Frank Bales and Tom Nick holding the bow of the boat. (Courtesy of Richard Beall.)

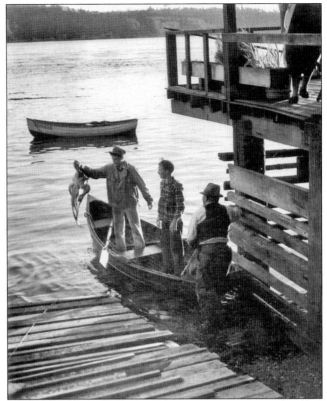

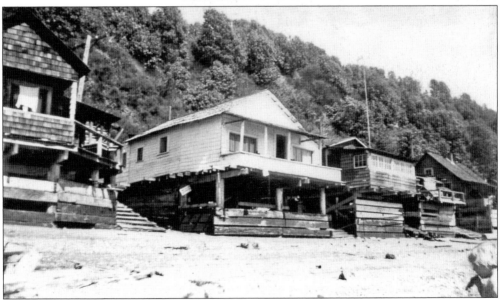

In 1940, Ed and Francis Lohr were proud to own this big white house, complete with hot and cold water and all the comforts of a house in town, except for sewers. Most cabins near the railroad tunnel were untouched by mudslides, but the danger of fire was always present. In fact, this cottage, on lot No. 93, was destroyed by fire in 1953, along with the neighbor's cabins. (Courtesy of Ed and Francis Lohr.)

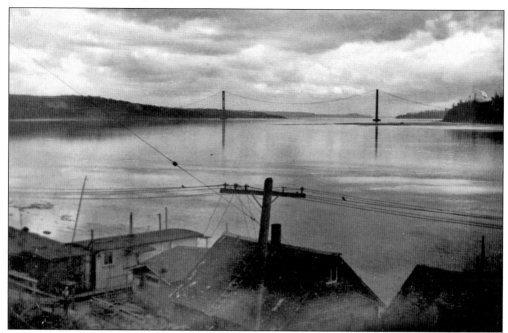

Walking down the main trail during World War II, the clouds hover over the ruins of the ill-fated Narrows Bridge. Leaving the war behind, a beach cabin provides all the fish one can eat, and all the driftwood one can burn. Electric lights made life much easier, too. (Courtesy of Marjorie Leftwich Thorpe.)

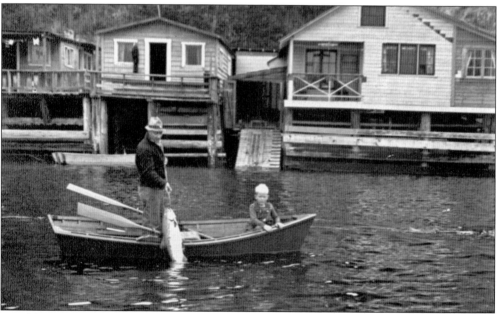

Harold Stamey enlarged his camp on the right, now No. 4, but rent remained low. During the Depression, the landowner's agent tried to collect rent from each camp owner. Karl Thompson or Ed Sherwood kept track of each account, often in arrears. For example, Sherwood wrote, "owe $10 to 12/31/32" after paying $5 on June 1, 1936. Herb Syford, of R. E. Anderson Company, took over in 1942. (Courtesy of Barbara Stamey Nolen.)

During World War II, many families with small children depended on older girls like Marjorie Leftwich and Lucille Gilbo for babysitting. Each day, a carload of workers headed to Todd Shipyard for both the day and swing shifts. Pictured at the foot of the north stairway, most of these kids did not stay after the war ended. (Courtesy of Marjorie Leftwich Thorpe.)

Frank Tuggle and Don Minor relax in their boat down by the tunnel. After Pearl Harbor, the Coast Guard required large numbers needed to be painted on all boats. Carl Pfitzenmeyer was appointed official Block Warden to remind beach residents of the new blackout rules. Patriotic residents doused lights and closed curtains, but never saw an enemy plane fly overhead. (Courtesy of Don Minor.)

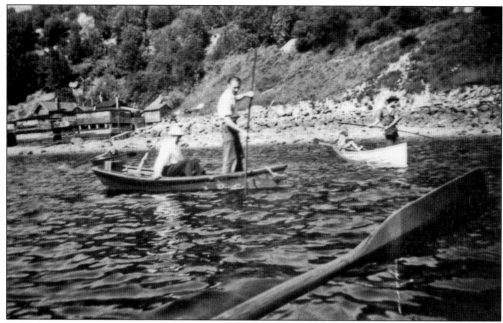

Ed Lohr and Patty McCartney rake herring in this photograph. In 1940, Helen McCartney and her four children, Marvin, Dennis, Ellen and Patty, moved to Salmon Beach, or "the end of the world." Like Helen McCartney, Louise Moon's children played with other beach kids, although they actually lived in Moon Hollow, south of the tunnel where the salmonberries grow. Her son George Moon delivered newspapers on the beach. He died in Worldd War II. (Courtesy of Ed and Francis Lohr.)

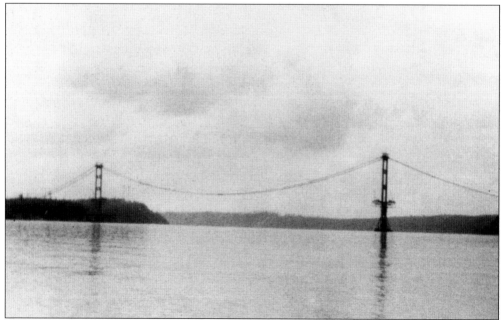

After the collapse of "Galloping Gertie" in 1940, towers and cables remained until construction of the new Narrows Bridge began in 1949. This is the view from the front porch of No. 7, which Ralph Eikenberry, a CPS student, bought in 1948. (Courtesy of Ralph C. Eikenberry.)

Four

EARTHQUAKE, EVICTION, AND LEGAL ACTION

1949–1958

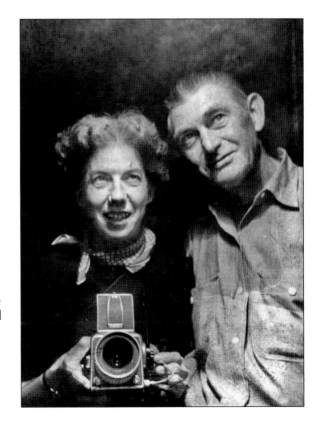

Virna Haffer took a photograph of herself and Denver Johnson in a mirror. Many Salmon Beach men, like Denver, were her models for experimental poses. Her husband, Norman Randall, died young and the last 25 years of her life were dedicated to professional photography and the creative uses of photographic materials. She wrote manuscripts for four books, but only one, *Making Photograms*, was published in 1969. (Courtesy of Virna Haffer.)

NOTICE TO VACATE PREMISES

TO Mr. H. B. Noonan and Jane Doe Noonan, his wife, and/or Occupant in Possession.

The undersigned have received notice from the Council of the City of Tacoma that the bank adjacent to the premises occupied by you has been declared unsafe, and that there is imminent danger of an earthslide, which makes your premises unsafe for occupancy. You are in this respect referred to the Official Notice given to all residents of the Salmon Beach Area by C. V. Fawcett, Mayor of the City of Tacoma, as of Monday, April 18, 1949. It is our understanding that the action of the City Council in this respect has been supported by the State of Washington and the American Red Cross.

In view of the foregoing, you are hereby notified that you are required to vacate the premises of the undersigned owner now occupied by you, situate and being in the City of Tacoma, County of Pierce, State of Washington, to-wit:

Camp Site No. __78__, Salmon Beach, presently rented or occupied by you.

In view of the foregoing, you are directed to remove your person, and any and all other occupants of said premises, at once from the aforesaid premises, and to further remove any personal property or improvements that you may have on the aforesaid premises, on or before December 31, 1949. Any person or property remaining on the premises at any time subsequent to April 13, 1949, shall be at your sole risk. You will be charged for all rent accruing prior to April 13, 1949, and will be refunded forthwith any rental prepaid beyond April 13, 1949.

You are hereby notified that unless you comply with the foregoing Notice and surrender said premises as aforesaid, the undersigned shall be required to proceed against you, as authorized by law.

DATED at Tacoma, Washington, this 22nd day of April, 1949.

JOHN S. BAKER INVESTMENT CO.,

By R. E. ANDERSON & CO., INC.,
Its Agent

This eviction notice was posted on Hank Noonan's door following a landslide in Point Defiance Park on Saturday, April 16, 1949. Eleven million cubic yards fell into Puget Sound, just north of Salmon Beach. Geologists said the landslide was triggered by an earthquake three days earlier, although no cabins were actually lost unlike previous landslides. Most residents were awakened by a thunderous roar at 3 a.m. Fortunately the tide was halfway out when the resulting eight-foot tsunami hit the cabins. Three geologists, Raymond Tarr, Weldon Rau, and Frederick McMillin, reported to the city council that Salmon Beach was within a dangerous slide area. The state attorney general was asked to determine if evacuation was necessary. When the state determined that residents could not be forced to evacuate, the landowner chose eviction instead. Hank knew it was time to get organized. On April 27, 1949, residents met at Anderson Hall, at Fifty-first and Pearl Streets, to organize a community club. The name Salmon Beach Improvement Club (SBIC) was chosen, and Hank was elected president. (Courtesy of the author.)

Hank Noonan saws firewood with a misery whip. His son-in-law John Lubon rigged up an intercom between the parking lot and the beach, which alerted listeners whenever thieves broke into cars at night. Hank signed the SBIC incorporation papers in 1950 with Fred Carlbom, Bill Douglas, Ralph Eikenberry, and Tony Marsh. During the Depression, this cabin, now No. 79, was owned by John MacIntosh, an old sailing-ship captain. (Courtesy of Bessie Noonan.)

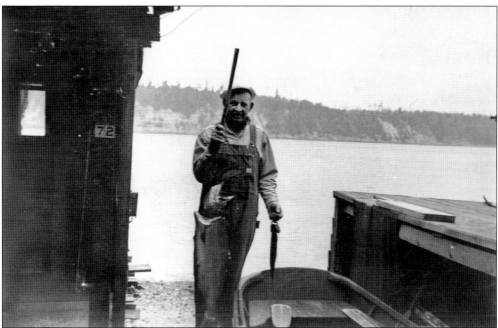

Hank Noonan holds up a salmon next to his doorway. Although the No. 72 is visible, all cabin numbers were changed in 1950 to match lot numbers assigned by the SBIC. Thus, 108 cabins were located on 111 lots, with some unleased lots being only 10 or 12 feet wide. Jim Wetherington, Bill Douglas's son-in-law, drew the map showing the front footages of each lot. (Courtesy of Bessie Noonan.)

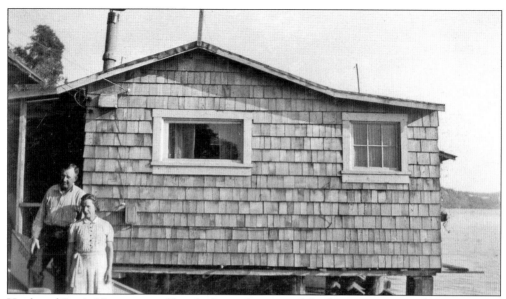

Hank and Bessie Noonan stand beside their cabin, one of the few remaining single-story cabins. The original front porch has been enclosed; after this photograph, another porch was added, which has also been enclosed. Each addition reduces the vertical distance between the ceiling and the floor, due to the slope of the roof. (Courtesy of Bessie Noonan.)

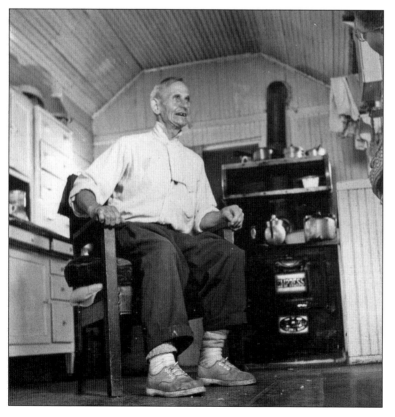

Emil "Benny" Benson, an ex-logger, bought Coley Anderson's camp in 1930 and lived in the same cabin for nearly 40 years. He spoke broken English with a thick Swedish accent, and cared for a large police dog. He was 87 years old when he died in bed in No. 12, just two months before a fire burned his cabin on July 30, 1969. (Courtesy of Virna Haffer.)

Ted "The Greek" Annos read the Bible at his kitchen table covered with an oilskin tablecloth. Ted used to make moonshine, which actually was a brandy made from any fruit. He "saw the light" and became a Christian fundamentalist, and even held prayer meetings in his No. 62 cabin. (Courtesy of Virna Haffer.)

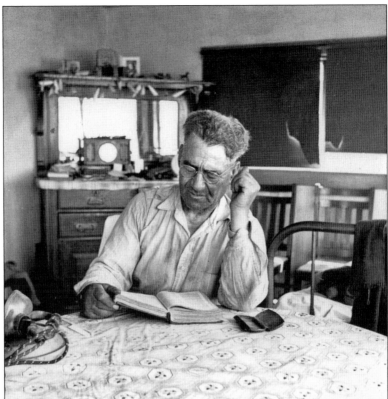

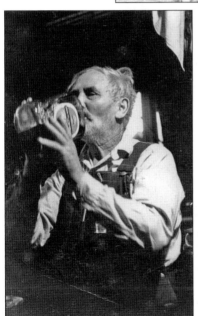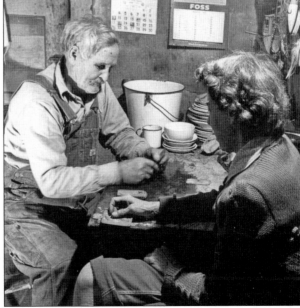

George Dilley deals greasy cards to Virna after shoving a stack of dirty dishes into a corner of his kitchen table. A heavy-drinking fisherman just needs a Foss tide calendar and fishing plugs carefully hung on the wall. George had no qualms about being photographed drinking from gallon jugs of cheap wine. (Courtesy of Virna Haffer.)

George Dilley's idea of housekeeping was to spread clothes on a line stretched above a mattress. There wasn't a closet in a one-room shack like Camp Kewaunee behind the Foss Boathouse. The pinups on the back wall show women who would disapprove, but his six children apparently didn't mind. (Courtesy of Virna Haffer.)

In the opposite corner was the wood range with a kettle of hot water and a coffeepot. Of course, no kitchen was complete without a 12-gallon crock for making home brew. (Courtesy of Virna Haffer.)

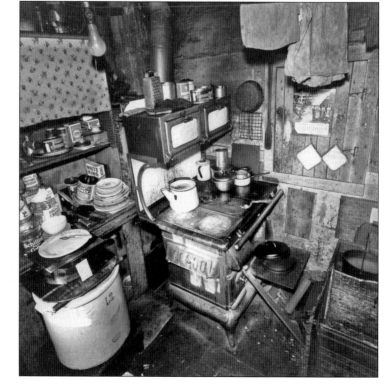

Paul Otto and Jake Flaat push logs away from the dock in front of the store, which also served as a movie theater and meeting room. When the new improvement club needed an address for the Articles of Incorporation in 1950, they wrote, "The registered office and post office address of this corporation shall be Salmon Beach Community House, Salmon Beach, Tacoma, Washington." Sixty-five years later, this article remains unchanged. (Courtesy of Virna Haffer.)

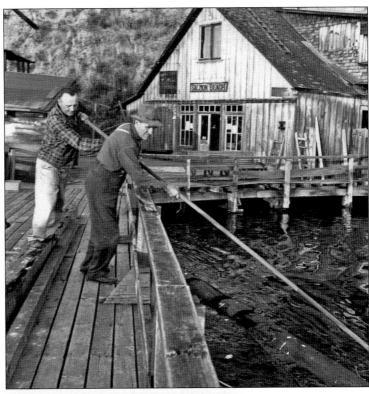

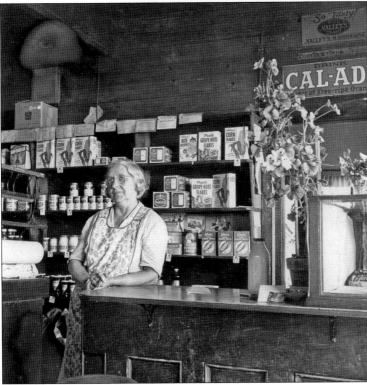

Inside the store, Ragna Pfitzenmeyer stood behind the counter. During the 1950s, only three families lived year-round in Salmon Beach, the Tallmans, Malleys and Jordins. Bud and Elva Weller, who owned No. 21 from 1936 to 1976, knew that the end was near. They sold People's Market to its employees when they realized that mom-and-pop grocery stores could not compete with Safeway. (Courtesy of Virna Haffer.)

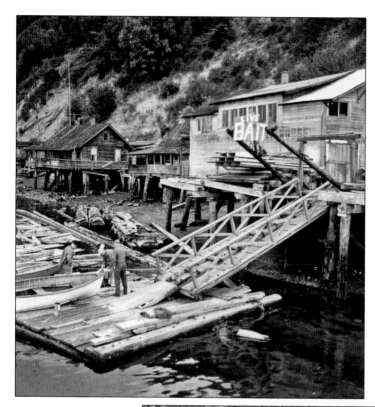

"Salmon Beach Boat House" is barely readable here, and the painted salmon had disappeared. John and Roe Bourgaize sold the boathouse to Henry and Oscar Rolstad. The last boathouse operator was Doris Irene Tallman, after both the Rolstad brothers got cancer. Doris recorded her autobiography from 1946, at age four, until leaving the beach in 1963. She was foreman at Buffelen Lumber and Manufacturing until her death in 1991. (Courtesy of Virna Haffer.)

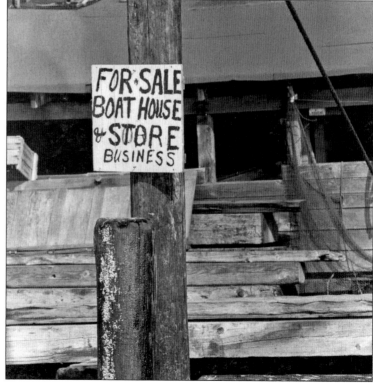

One sad day this sign appeared, but there were no takers. In 1950, Henry Foss agreed to rent the tidelands to the SBIC since Baker had evicted everybody. This action forced Baker to prove that he owned the narrow strip underneath most cabins between the high water line and the government meander line. After carefully checking titles, residents learned that the state still owned this strip of tideland. (Courtesy of Virna Haffer.)

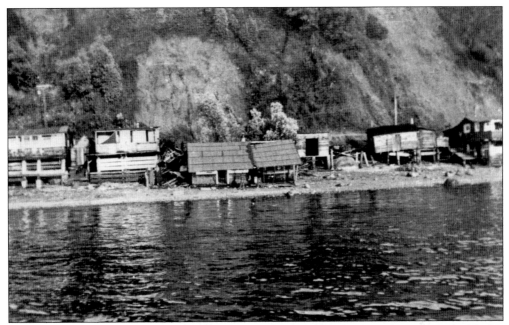

In February 1951, a mudslide hit Joe Wetherington's remodeled cabin on today's vacant lot No. 77. The previous winter a blizzard left two feet of snow on the ground for weeks. Joe's wife, Elizabeth, was the daughter of Bill Douglas, a club incorporator. Club president Hank Noonan moved to the Day Island sandspit. Another incorporator, Tony Marsh, moved to Spanaway Lake. Leadership then passed to George and Hortense "Hoyt" Girard. (Courtesy of Virna Haffer.)

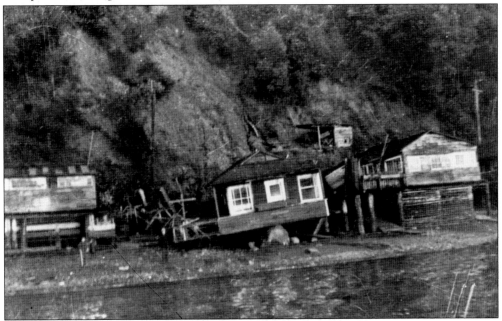

Leo and Charlotte Reis's cabin, where No. 61 is today, was another mudslide victim. Charlotte, the daughter of Otto and Fern Mims, lived her entire life on the beach until this tragedy. They moved to Midland, far from the saltwater. All three cabins pictured were rebuilt in 1970. (Courtesy of Virna Haffer.)

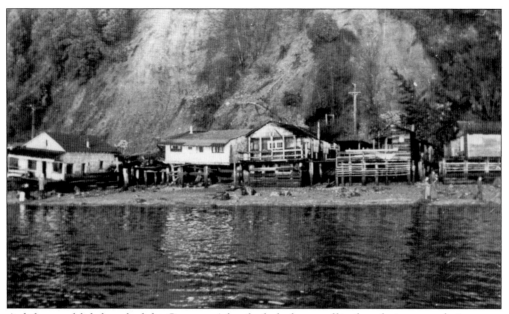

At left, a mudslide knocked the Crossman's lovely shake house off its foundation on today's vacant lot No. 80. Now, 50 years later, the barren hillside is once again covered with alders, blackberry vines, and Scotch broom. Cabin No. 79 remains all alone, the only cabin with a large vacant beach on both sides. (Courtesy of Virna Haffer.)

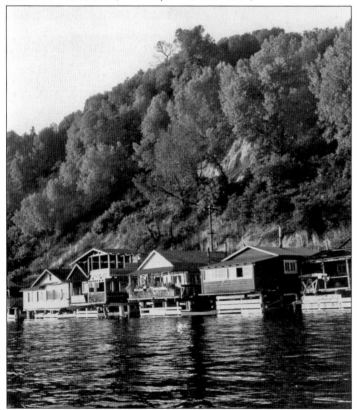

In February 1953, another multiple-cabin fire burned these four cabins, Nos. 91 through 94. The fire started in the third cabin from the left, owned by Henry and Elsie Paulson; television wiring was blamed. A trail of winds came through a thick grove of madrona above these cabins to the former south parking lot, now part of a scenic subdivision of upscale homes known as Parkside. (Courtesy of Virna Haffer.)

These stairs lead to a parking lot known as the Hole. The name of "improvement club" was just wishful thinking for dues were only $2 per year and there wasn't much money for maintenance. When the community lost the old south lot after 1977, the Hole became the new south parking lot, which was eventually expanded and paved in 1990. (Courtesy of Virna Haffer.)

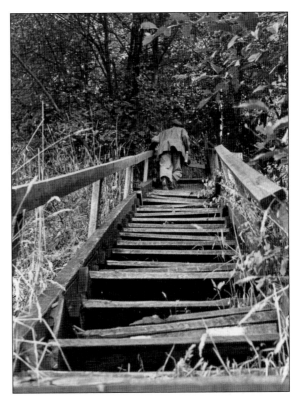

The old south parking lot was just a wide spot in the fire road that meandered along the bluff above the railroad tunnel. During the 1950s, the Tacoma-Pierce County Health Department complained about garbage dumping along this extension of North Fifty-first Street. Some of these dilapidated garages built during Prohibition had stored moonshine for sale by "Big Al" Fugina. Now the street is called Scenic View Drive. (Courtesy of Virna Haffer.)

Before 1969, a dirt road leading to this parking lot began at a fork in the road near North Fifty-first and Vassault Streets. Kids walked through the swale, past the old gravel pits, to Point Defiance School. They would also lie on top of the garages and watch lovers necking in their cars at night. Louie Bay cherished his 1936 Plymouth. Dallas and Edna Bell owned the big Buick. (Courtesy of Virna Haffer.)

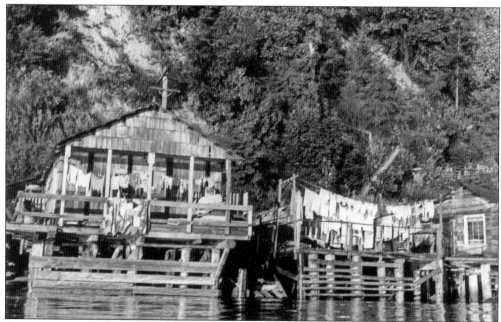

Before electric clothes dryers, an open porch or deck made a perfect place for a clothesline. Nobody carried clothes up the hill to a laundromat. Doris Tallman remembers George Dilley just stuffed his bib overalls and long johns in an onion sack, and jigged them in the Narrows. After they dried, the salt made clothes stiff, but it didn't bother him. (Courtesy of Virna Haffer.)

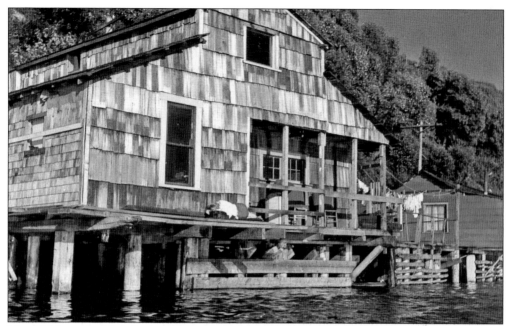

Harold Munn doubled the size of the above cabin, now No. 82, by expanding onto vacant land where cabin No. 81 had been destroyed by the 1951 mudslide. Richard Turner paid $44.50 to Warren Anderson for this unfinished cabin in 1964. Richard and his new wife, Nancy, a beautiful red-haired Texan, were marooned here for three days after the back porch entry collapsed in a winter storm. (Courtesy of Virna Haffer.)

Jane Tallman, another redhead and one of Les and Gert Tallman's nine children, sits next to her sister Anne. Their cabin, now No. 26, was behind the boathouse, which Doris Tallman remembers tearing down to deck level in 1960. The deck later floated off its piling at high tide. Doris moved into Oscar Rolstad's cabin and stayed on the beach long enough to finish high school, keeping her promise to Oscar Rolstad. (Courtesy of Virna Haffer.)

Doris Tallman remembers her mother heating spring water on the wood stove to fill a ringer washer. She hung diapers, a few towels, and handkerchiefs on a double line stretching along the boardwalk to Oscar Rolstad's house, now No. 28. North of the store, a boardwalk ran between cabins next to the bank and the Foss buildings and rental cabins on the waterside. (Courtesy of Virna Haffer.)

The last section of trail leading to the dock between the boathouse and store was just planks nailed on wooden trestles, three feet wide, with ribs set across to prevent slipping when wet. The of the Foss Boathouse, originally the Foss family home, was supported on 1-by-12 joists of roughcut cedar above the boat storage downstairs. Builders were skeptical, according to Henry Foss, but Andrew nailed wooden crossbracing between the upright joists. (Courtesy of Virna Haffer.)

Ralph Jenks kept his cabin much more hospitable than did George Dilley, which included a chunk of old-growth fir covered with fresh newspaper, tea in Mason jars, and a rocking chair next to a wood stove. Ralph was Virna's best model for her photographs. The author owns a print of her famous *Maestro*, with Ralph and a borrowed accordion, which was exhibited throughout the United States. Ralph actually played the Jew's harp until his lips bled. (Courtesy of Virna Haffer.)

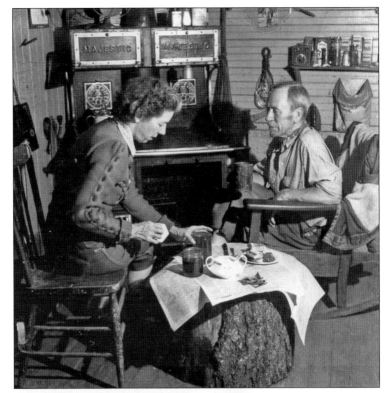

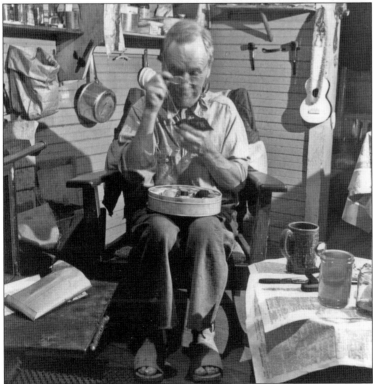

Ralph Jenks could sew a button on his shirt or mend a sock. He had been married before World War II, and the newspapers photographed Ralph and his wife, Barbara, riding a two-seat bicycle from Seattle to San Francisco for the World's Fair. Ralph rented the north end of the Foss "double house," now No. 23. (Courtesy of Virna Haffer.)

Jake Flaat stares out from the Boxcar, now No. 38, pondering Salmon Beach's fate. Bob Copeland, a war hero and author of the *Spirit of the Sammy B.*, was the SBIC's attorney since 1949. Just before the state's public auction of land under most cabins in June 1955, Baker's lawyers sued the state, which lost in superior court. Bob Copeland appealed to the state supreme court as intervenor appellants. (Courtesy of Virna Haffer.)

Virna Haffer and Denver Johnson play cards at Martin and Anna Shevlin's cabin, now No. 104. The upland owner, John S. Baker, died in April 1955. The state's half-hearted appeal to the Supreme Court lost in 1958, giving the Baker heirs clear title to the disputed tideland ownership. But the tidelands owner, Henry Foss, son of humble Norwegian parents, refused to deal with the Baker's haute agents and downtown lawyers. (Courtesy of Virna Haffer.)

F. W. "Mac" MacAlpin owned the cabin built by Carlton Fuller with No. 1 finished lumber towed from the Hammerschmith sawmill on Portacoma Road. As a club director, he understood the "wait and see" attitude was too great a risk. In October 1956, he paid Northwest Movers $1,500 to move No. 44 to Parkland, south of Tacoma, the last of four cabins to move off the beach after April 1949. (Courtesy of Virna Haffer.)

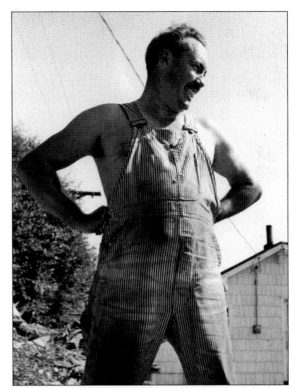

Paul and Kay Otto owned this attractive cabin on Foss tidelands, now No. 37. He loved taking 8mm home movies of his flowers, family barbecues, and the attractive Tallman girls. Unlike most residents, Paul was actively involved in Republican politics, which got him a job as a deputy sheriff in 1952. Bare-chested Paul was a showoff, who would dive off his roof into Puget Sound in the summer. (Courtesy of Virna Haffer.)

Visitors stand on the front deck of Virna Haffer's cabin, where No. 52 is today. The bare hillside, visible above her cabin, is evidence of a recent mudslide that destroyed Charles and Mary Bishop's cabin in 1950. When the slope of a porch roof is extended, it's often too low. So, Jim Ehrler built a higher roof for both Nos. 51, on the left, and 52. (Courtesy of Virna Haffer.)

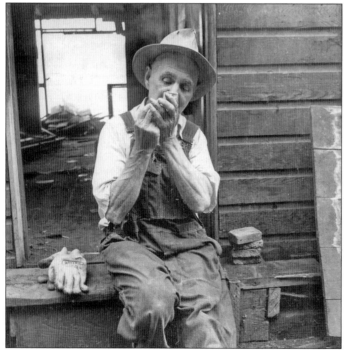

Otto Mims's arms are those of a real fisherman. Even Ivar Haglund drove down from Seattle to buy octopus from Otto. He moved to larger cabins four times, his last one being No. 54. But this day, Ragna Pfitzenmeyer hired him to tear down Len Garner's vacant cabin No. 59, formerly Camp Stick It Inn. Originally from Mississippi, Len's cousin was John Nance Garner, Pres. Franklin Delano Roosevelt's vice president. (Courtesy of Virna Haffer.)

The door hangs open with no "Open" sign needed. The large sign over the door was stolen, but rumored to still exist in an Olalla basement. Foss branded each boat and oar, and the branding iron was found, but then stolen also. The walls are board and batten, typical for balloon construction before fire stops at each floor level were required. Virna knew that the end of the old store was near. (Courtesy of Virna Haffer.)

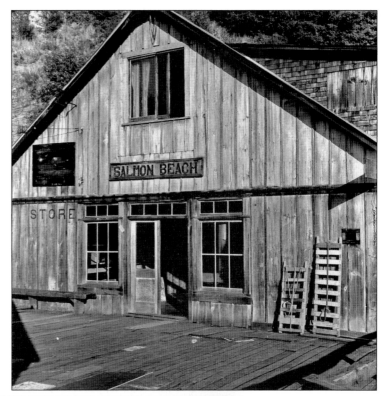

Jane Tallman is smiling here. She remembers her teacher asking, "What is your address?" Jane replied, "Twenty-six and a half Salmon Beach." The teacher then asked, "Is that all? No Road? No Street?" "We live on the water," replied Jane. All the Tallman children wanted to get off the beach. Jane married Gil Olson and got her wish—a home in Roy, far from the water. (Courtesy of Virna Haffer.)

The defiant expression on Beverly Malley's face warns, "Don't mess with me, buster" and harkens the Garrison Keillor saying, "where all the women are strong." Yes, there are similarities between Salmon Beach and Lake Wobegon from the popular radio show "Prairie Home Companion." The Malleys, with five children, needed a larger cabin, so they bought No. 102, which had a second story built by navy seabee Ed Knudsen. (Courtesy of Virna Haffer.)

J. Albert Malley got his guitar back. The Malley children became extroverts with lots of energy. The oldest son, known as "Bouncing Bob" Malley, did stunts on his motorcycle for parades and married Nancy "Dee Dee" Smith, whose parents owned No. 111. His younger brother Tiny married LaDonna Grubb, whose parents owned No. 92, and later got hitched to Diana Innes, whose parents owned No. 105 before it burned in 1948. (Courtesy of Virna Haffer.)

Behind the last cabin at the north end of the beach, Clarence Potter rigged this electric porch light from an old railroad lantern. Next to it, a birdhouse made from a Log Cabin syrup can looks appropriate. (Courtesy of Virna Haffer.)

Here's the hand pump behind No. 95, which supplied water to cabins in the vicinity. The south half of the community did not have freshwater springs above a clay bank like camps closer to the store. So ambitious men like Bill Douglas would dig a shallow well. If dug too deep, the water would taste salty, like the well behind No. 87. (Courtesy of Virna Haffer.)

Winter storms often wash out sections of trail behind the cabins. Waves crashing against a weak bulkhead will lift rotten planks, allowing seawater to erode the backfill, which is often rotten wood or stumps. When this happens, the urgency to fix the trail means that another poorly constructed bulkhead is hurriedly built. So the cycle repeats, unless a major bulkhead-rebuilding project occurs during the summer months. (Courtesy of Virna Haffer.)

When building inspectors look the other way, beach camp construction can take some bizarre shapes. This second-story addition is cantilevered over the boatslip, and it's supported by a porch cantilevered out from the pilings beneath the cabin. Soon after this cabin burned in 1953, Milt and Evelyn Grubb built a new cabin, which was torn down and reconstructed by George and Lynda Jay, now No. 92. (Courtesy of Virna Haffer.)

Lucky Strike, like the other cabins built on Foss tidelands, looks unmaintained and unoccupied. The cabins north of the store were torn down to deck level by the cabin owners behind them. Since nobody was behind this cabin, neighbor Ed Johnson converted Lucky Strike into a flat-roofed boathouse. Then, Mike Tucci added a second story and replaced the siding. With fresh paint this "fixer-upper" is now No. 36. (Courtesy of Virna Haffer.)

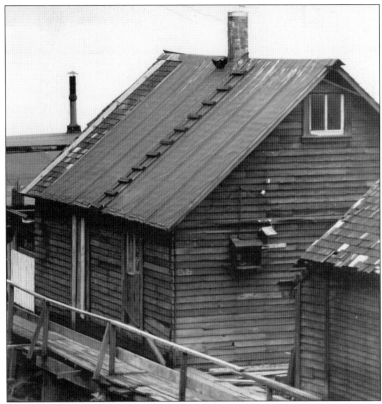

On the left, the north end of the boathouse sits empty. George Dilley shuffles along the boardwalk toward Camp Kewaunee behind the walkway. White smoke billowing out of the chimney indicates wet wood burning in this rental cabin in front of No. 26. Note the wooden slats across the windows to keep the drunks from breaking the glass. (Courtesy of Virna Haffer.)

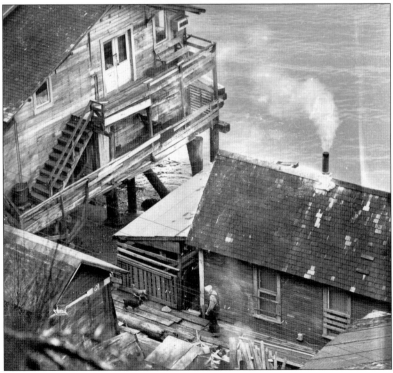

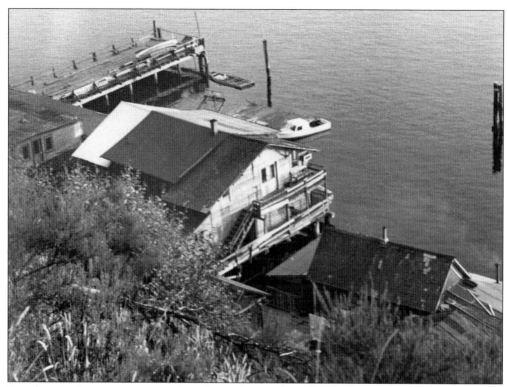

Standing further away, one sees the relationship between the dock and the old Foss Boathouse at left, and the large boathouse annex with an upstairs apartment. Some residents moved their boats in or out from their cabin by attaching it to a clothesline between the deck and a pulley attached to a dolphin in front of their cabin. This prevented the boat bottom from scraping the rocky beach at low tide. (Courtesy of Virna Haffer.)

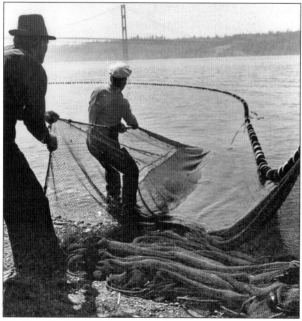

Jake Flaat helps Willard Pfitzenmeyer pull in the beach seine by the railroad tunnel with Narrows Bridge in the background. At night, fishing boats still catch herring in this area to be sold as bait at the Point Defiance Boathouse, but nets with cork floats haven't been used for years. (Courtesy of Virna Haffer.)

Harry Paulson's boat got scorched in the fire that burned their No. 93 cabin. He and his wife, Elsie, moved to No. 51 and parked this boat on a ramp at vacant lot No. 50. Harry and two friends drowned in this boat in 1960; some accidental drownings were predictable. One instance was when one-armed Emil Racicot fished with a rubstrap wrapped around his wrist and a big fish dragged him over the stern. (Courtesy of Virna Haffer.)

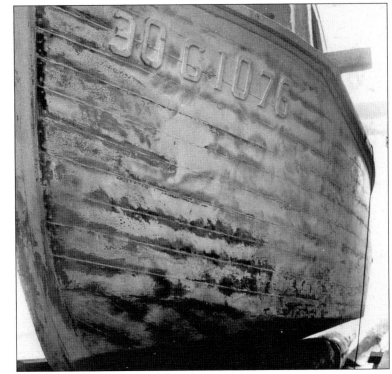

Walking north from the store, one passed by a double-row of boat lockers on the left, then underneath the front porch of the old Foss Boathouse. Upstairs, Oscar Rolstad looks out at the water through the clothesline. When the store and boathouse closed, this unlit area was spooky for kids at night. (Courtesy of Virna Haffer.)

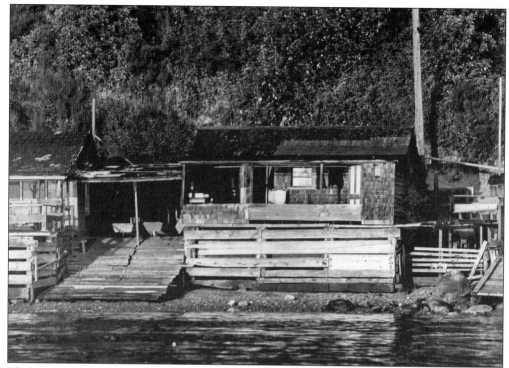

There was enough space between Nos. 99 and 100 for a double boat ramp. The enclosed outhouse with the high window on the right end of the front porch was a standard feature of beach cabins. In later years, a young lawyer bought No. 99 and decided that he needed a new bathroom more than a boat slip. (Courtesy of Virna Haffer.)

In 1940, Aaron Jones bought the Doohans summer cabin, No. 73, and renamed it Shawnee. His grandson, Bob Jones, became quite an entrepreneur in Tacoma, operating seasonal sales of flowers, fruit, and Christmas trees next to the A & W on Sixth Avenue. When the highway department expanded the State Route 16 interchange, he negotiated a move to the current location of Tacoma Boys at Sixth Avenue and Winnifred Streets. (Courtesy of Virna Haffer.)

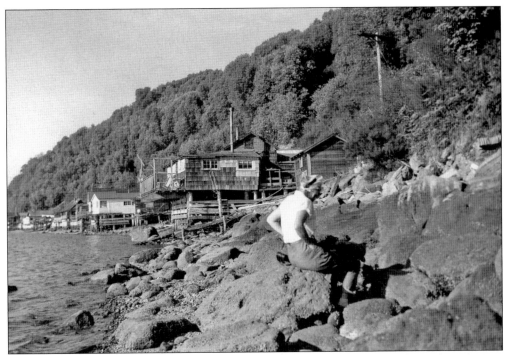

Agnes Oldenbourg sits on the riprap below the tunnel in October 1958, a significant date, as it was the time the SBIC gave up all hope of winning in court. In a late night phone call to George Girard, Virna Haffer cried, knowing that only her photographs would last. The battle for survival that began in April 1949 ended almost 10 years later. (Courtesy of Joachim "Ocki" Oldenbourg.)

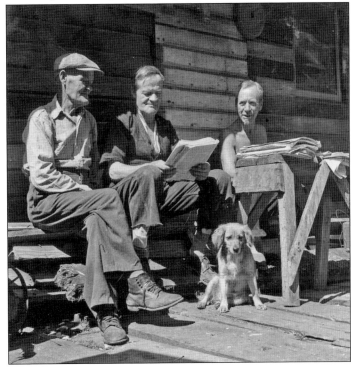

Ole Berg, Frank Neuman, and Ralph Jenks sit next to the walkway north of the store. Newspapers are piled on a rough homemade bench built with scrap materials that would probably be burned today. (Courtesy of Virna Haffer.)

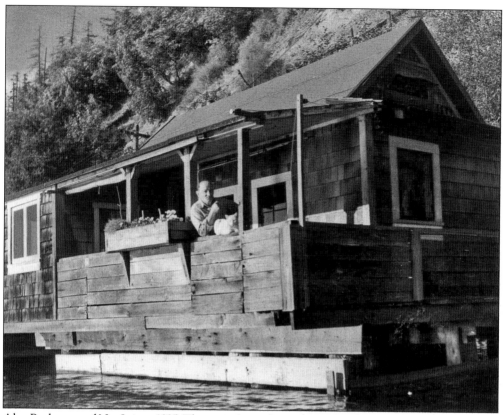

Alex Paulos owned No. 8 since 1935. The typical cantilevered open porch with an enclosed outhouse at one end is seen here. Like so many Greeks, his last name was shortened, from Panagiapolis to Paulos. He was well known for his octopus salad. (Courtesy of Virna Haffer.)

Alex Paulos had a twinkle in his eyes that his next-door neighbor Ralph Eikenberry still remembers—one of a happy Greek who worked for several restaurant businesses. (Courtesy of Virna Haffer.)

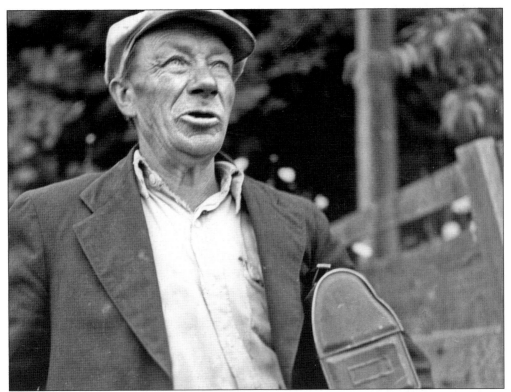

Helge Johanson, an old windjammer sailor, and his wife, Betty, bought No. 65 in 1942. After he died in 1959, Al Vandenberg, an old Hoosier, and his fishing buddy Mike Slavich bought it together. When Mike died, his son offered to sell his father's half-share to Al for $350, but Al couldn't afford it and had to move. (Courtesy of Virna Haffer.)

Oscar Gilbo needed a long, sturdy ladder to paint No. 49, built by Bill and Ann Clinton in 1939 from lumber salvaged from the Narrows Bridge construction. After several changes in ownership, two young women found it advertised in the Little Nickel Want Ads for only $3,000 in 1973. No longer cute, the roof was ripped off to add a second story. (Courtesy of Virna Haffer.)

Charley Tallman doesn't look too happy. It's a tough life growing up with five older sisters (Marilyn, Jane, Linda, Doris, and Judy) in a small cabin like No. 26. As he got older, he built his own tiny cabin. On a happier day, Paul Otto treated all the beach kids to a free Republican Kids Frolic at Pony Lake Park in North Puyallup. (Courtesy of Virna Haffer.)

At left, Charles "Shorty" Rupprecht enjoyed retirement from Tacoma City Light. The front of Shorty's cabin No. 3 appears different after 1938 because of an addition made from rough shiplap. The high-curtained window indicates a possible indoor outhouse. Obviously a picture window was not needed, just a door. (Courtesy of Virna Haffer.)

Five

LEASED LAND, HIPPIES, AND BLIND FAITH

1959–1977

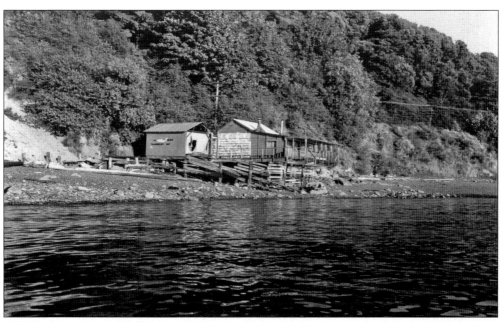

UPS history professor C. Brewster Coulter and his wife, Betty, owned cabin No. 111, known as Tranquillity Gap. In 1959, the SBIC negotiated a master lease with Herb Syford, the Baker estate's agent. Cabin owners received written subleases for the first time. However, the new landowners, the Wiborgs, left this cabin out of the land purchase in 1977. Only the pilings remain today. (Courtesy of Richard Turner.)

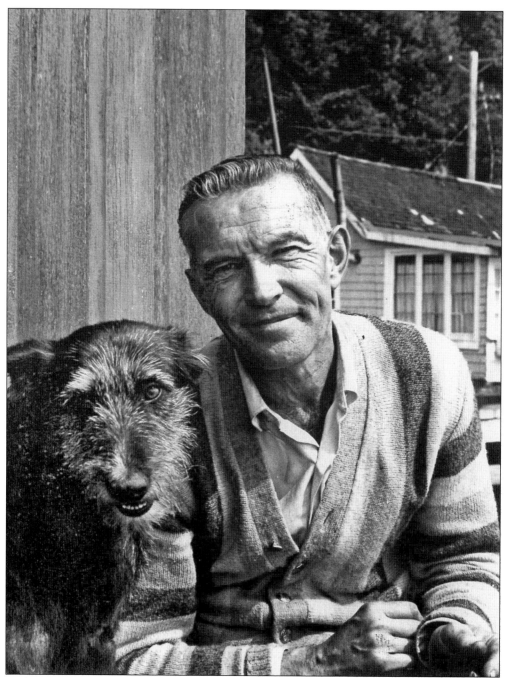

Richard Hadden Harkness was voted "most likely to succeed" by his 1940 high-school classmates in Muskegon, Michigan, but success was limited to picking brush on the Kitsap Peninsula after seven years in the army. Unable to support his three children in Allyn, he paid $350 for the Boxcar in 1961, now No. 38. While delivering newspapers, he would learn what UPS students were throwing the next beer party. The younger hippies admired his humble lifestyle that spurned ambition. A double-ended extension cord connected next door provided power to electric circuits made from telephone wire. He died at age 50 in 1971.

Richard Harkness stands on the walkway behind the Boxcar, looking north toward the store. The motley collection of lumber at right had been actual camps prior to the mudslide of 1933. Today a new bulkheaded trail follows the foot of the clay bank. Richard's chosen lifestyle fits this poem, found in his cigar box of personal papers:

"Magna Est Veritas"

Here, in this little Bay
Full of tumultuous life and great repose,
Where, twice a day,
The purposeless, glad ocean comes and goes,
Under high cliffs, and far from the huge town,
I sit me down.
For want of me the world's course will not fail,
When all its work is done, the lie shall rot;
The truth is great, and shall prevail,
When none cares whether it prevail or not.

—Coventry Patmore, 1877

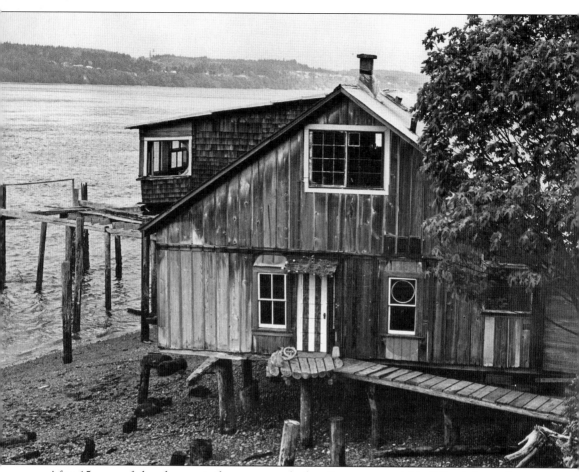

After 15 years of abandonment, the store was the last Foss commercial building left standing in 1968. Corrugated tin covering weathered shingles stopped most leaks. A few hippies decided to move in without asking Henry Foss. They even made some improvements to the south entrance, but the structural support under the front wall and overhanging dormer was gone. Foss worried about allowing transient occupancy of his abandoned building. His solution was to tear it down as long as he didn't have to pay for it, like the boathouse five years earlier. Bill Hardy and his brother-in-law Joe Skach had lost their cabins in the July 1969 fire and offered to tear down the store and its dock if they could rebuild modern houses there, now Nos. 32 and 33. (Courtesy of Emmet Yeazell.)

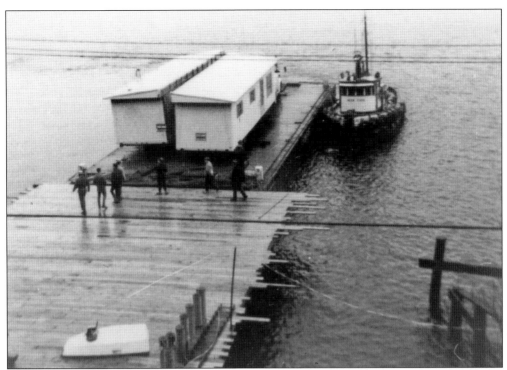

During the summer of 1970, three large platforms were built on 60-foot-wide lots on Foss tidelands before the Shoreline Management Act prohibited new over-water construction. While the Hardy and Skach's houses were being constructed, Lester and Ann Wagner had a different idea—a mobile home. Charlie's Trailer Sales in Tumwater said they would deliver anywhere, so Les and Ann just smiled and said "okay." (Courtesy of Les Wagner.)

The harbor tug *Drew Foss* towed the double-wide mobile home on a barge from the Port of Tacoma around Point Defiance, timing the tide perfectly. A tractor truck backed each half onto the new deck in 45 minutes. Wheels and axles were removed, and the mobile home became a permanent fixture, now No. 34, where Camp Waltonia had been. (Courtesy of Les Wagner.)

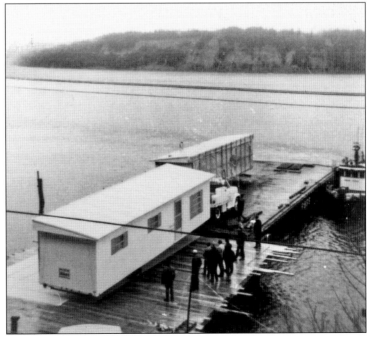

The author, a state highway engineer, appears dazed with his three neighbors (two of whom are visible) sunbathing behind him. In 1959, George Girard managed to talk Herb Syford, Baker's agent, into giving short-term land leases for two or three years to the cabin owners. No bank would lend money to buy cabins on short-term leases, so the author would finance many new owners like Jan Allen and Marilyn Kimmerling. (Courtesy of the author.)

Although tolerant of most hippies, many neighbors were pleased to have Paul Larson buy No. 97 in April 1972. The previous owner, one of the "blanket people," preferred to go barefoot rather than wear "dead animals," i.e. leather, on his feet. Paul loved to recondition old cars, so his goal was to save this cabin as well. (Courtesy of Paul Larson.)

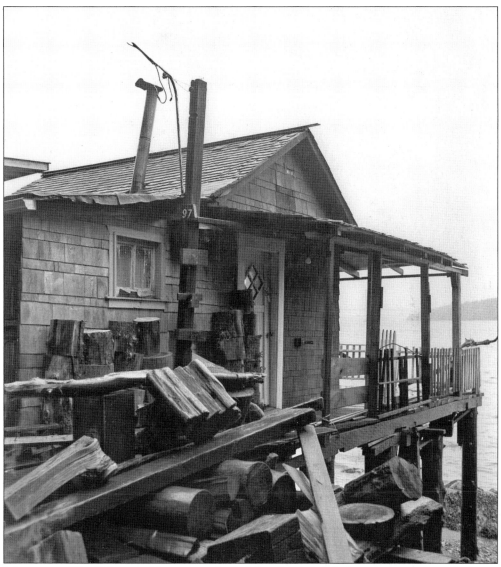

Like many of Paul's heavy old cars, mostly Cadillac "lead sleds," the cabin was in rough shape. But it had many unique features, such as the diamond-shaped, four-pane window in the side-door entry. Paul followed Roger's advice to use house numbers cut from old license plates. Built in 1916, this was one of the few original cabins left along this waterfront bazaar of vernacular architecture. Before 1949, Walter Crooks lived here. During World War II, the Home Guards hired him to guard the railroad tunnel, his last job. Paul cherished the past, and even placed a round oak table with poker chips and cards on the front porch. While most cabins had replaced outdoor privies with bathrooms, Paul built a separate outhouse and shower opposite the side door. (Courtesy of Ron Karabaich)

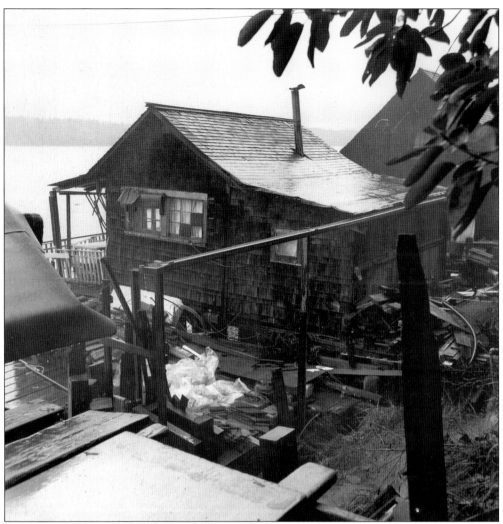

The cabin's interior size was only 14 by 17.5 feet, plus an open front porch—just right for a bachelor, but too small for a family. One previous owner, J and J Associates, used it as a cozy nest for a secret lover's tryst. Transfers of cabin ownership only required a bill of sale and were often unrecorded. Sometimes the SBIC had difficulty tracking down the current owner to collect land rent. In the case of J and J, a telephone call to the wife, unaware of her husband's love affair, prompted a quick sale. Of course, the public perception of the hippies taking over the community was exaggerated. Many cabins remained as summer homes for citizens such as Isabel Havel. Mayor Gordon Johnston, an architect, helped by squashing enforcement of many infamous stop work orders, called "red tags." (Courtesy of Ron Karabaich.)

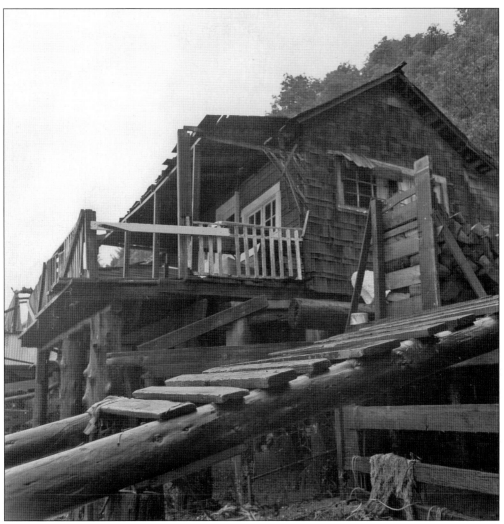

Paul Larson's first priority was to restore the roof over the front-porch railing. First, some additional posts were needed. All cabins are supported by posts, set into hand-dug holes in the beach gravel or clay. Usually pieces of creosote piling last much longer than untreated wood. But soft cedar posts, pictured in the first row of this photograph, are much lighter and easier to raise off the beach. Regardless of the material used, posts are called "piling," although technically incorrect. When posts need replacement, the stumps are often left in place. William Hocking, a legendary local architect, said, "The indigenous architectural growth is more significant than architectural experiments such as Jim Ehrler's house," now No. 61. Jim and Carol Ehrler were very active in building or remodeling four beach cabins, and Jim is still known for radical, often spectacular, architectural ideas. (Courtesy of Ron Karabaich.)

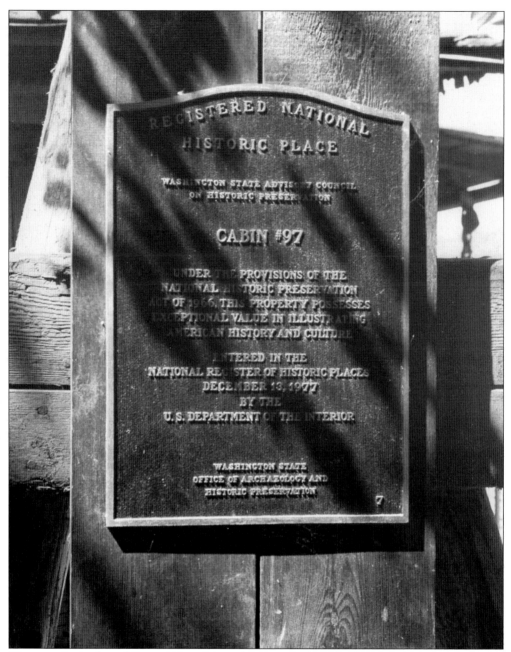

Not everybody shared Roger Edwards's enthusiasm for historic preservation, especially the Wiborgs, who felt that federal protection of one historic cabin without their consent threatened their property rights. Negotiations led by Sondra D'Ambrosio, George Jay, and Greg Bedayn started in early 1977 to buy a 150- by 2,080-foot strip of land, mostly steep hillside, under the majority of the cabins. The City of Tacoma's attitude had also changed. The key decision made on December 12, 1973, by the Tacoma Planning Commission, reversed the city's official position from removal to preservation of the historic community in the Shoreline Master Plan. Each member of the planning commission received the first issue of the Salmon Beach Historical Committee's newsletter, dated November 1973. (Courtesy of Ron Karabaich.)

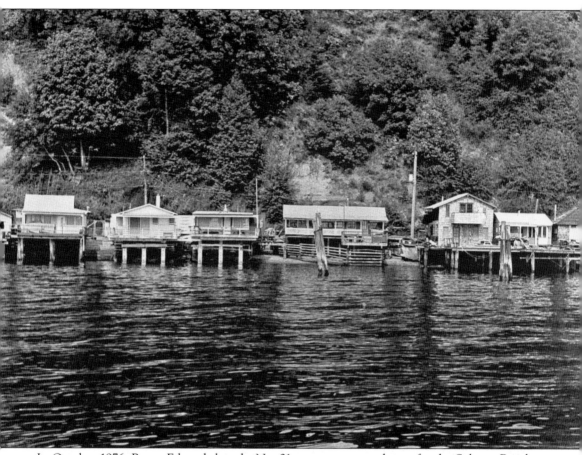

In October 1976, Roger Edwards bought No. 21 as a permanent home for the Salmon Beach Historical Committee, now a society. Joan Madson was the first caretaker, followed by Ginny Durham and Caley Bovee. This structure, fourth from the left, is another original cabin built in "shotgun" style with a full-length open porch. Now one of the few single-story cabins left, it was moved 28 feet away from the bank in 2001 to decrease risk from future mudslides. (Courtesy of the author.)

In February 1977, the Salmon Beach Historical Committee moved its activities to No. 65, where Steve Overland and Ginger Connelly built a community hot tub. As water heated on the first night, the electric wires glowed red hot above the transformer. Soon it was learned that a 3-kilowatt transformer, designed for no more than light fixtures, was no match for a 12-kilowatt hot-tub boiler. (Courtesy of the author.)

A small mudslide within a thicket of blackberry vines blocked the trail behind No. 39 in February 1972. The cabin owner, Roger Edwards, set up a detour over the roof with four ladders. Later, his neighbors hacked a hole through the thicket with machetes. He sold this cabin in 1973 to Yvonne "Bonnie" Hoover for $3,900, and bought it back from her ex-husband, Greg Newton, 30 years later for $150,000. (Courtesy of the author.)

The high point of community spirit was the entry of the Salmon Beach Slugs in the Seattle Seafair Tug-of-War competition in 1977. The team practiced at Bill Frickelton's "dojo" at the Tacoma Japanese School on Tacoma Avenue. The prize money was $10,000 and would have been donated to the land purchase fund if the team succeeded. Pictured here, from left to right, are (first row) Rachel Button, Napier Wright, Dave Maxwell, Dick Meyer, Tamie Herridge, and Richard Turner; (second row) Mary Lou Bell and Ben Percival; and (third row) Rosemary Cloherty, Dave Percival, Tim Holland, Helaine "Lainy" Beitler, Roger Edwards, Jae Frickelton, Bill Frickelton, John Wheelock, Jerry Sandstedt, Joan Madson, and Tom Echert. The team beat Goldie's Forty-fifth Street Tavern, but unfortunately lost on the second round. (Courtesy of John Wheelock.)

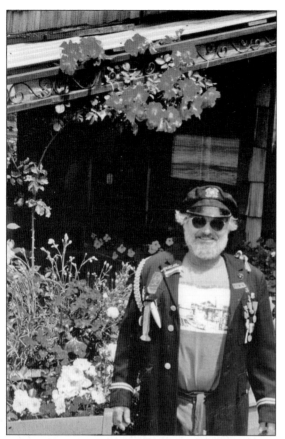

Richard Turner started another community tradition in 1970 with an annual rowboat race, on the Fourth of July, the full length of the beach. Commodore Richard, the artist, produced original posters that are now collectibles, and handed out ersatz trophies at the end of the race. Emmet Yeazell, from Sausalito, was vice commodore, a role now filled by Ralff Somoff. (Courtesy of Helen Gatti.)

At the end of the race, Joan Rutherford often hosts a party at No. 1. Joan has given generously to the community since 1977, except for five years when she lived on Mili Atoll in the Marshall Islands. At the celebration a beer keg usually appears; the early winners welcome the late arrivals, such as Mike Gilmour in his wet suit. In recent years, the kayak competition has been especially enthusiastic. (Courtesy of Helen Gatti.)

Six

LAND OWNERSHIP
AND SOCIAL CHANGE
1978–PRESENT

After 1969, the intersection of North Fifty-first and Mildred Streets became the only access to Salmon Beach. Barely visible at right is a steep winding road that ties into the old lower Salmon Beach road. At left, the old upper Salmon Beach road continues past the old gravel pits, now filled in. Peter MacDonald designed this sign. (Courtesy of Marilyn Mahoney.)

Driving west on North Fifty-first Street, there is double-armed swinging gate. Red-and-white reflective tape shines brightly on each arm at night. A sign mounted on a light standard above the gate states "warning," but the fine print can't be read below it. A box made of heavy-gauge steel holds a button pad for access codes to enter this now gated community. (Courtesy of Chip Van Gilder.)

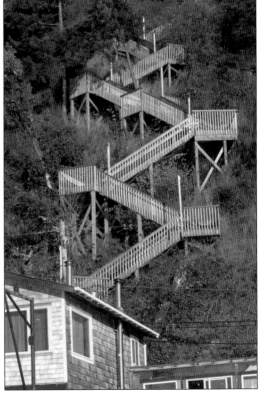

Trails and steep stairways are still the only means of access from parking lots on top of the bluff. One wealthy homeowner offered to build a tramway, but after considering the cost of maintenance and liability for mechanical failure, the community turned down the offer. Visitors are amazed that residents are willing to walk up and down over 200 steps. The legendary woodworker, Ed Fahnoe, is usually involved in every major building project. (Courtesy of Chip Van Gilder.)

Marilyn Mahoney stands beside Chloe, a life-size bronze mermaid, which is larger than the famous mermaid in Copenhagen's harbor. The unveiling of Chloe was celebrated on June 10, 1995. This is a destination for young children who like to put shells in Chloe's tail and seaweed in her hair. Marilyn dedicated her sculpture to Anita Garric, a friend who wanted to be reincarnated as a mermaid. (Courtesy of Chip Van Gilder.)

During winter storms, Chloe sits unperturbed as waves splash over the trail behind her. She is bolted firmly to one of several large boulders, known as jade erratics, which were brought down by glaciers from Canada. Marilyn's daughters were the models for Chloe. The names of many that helped with her creation are inscribed in the scales. Boaters do a double take when they cruise by. (Courtesy of Mary Campbell.)

As the horsepower increased, a motor's weight became too heavy to lift and boat slips became increasingly scarce. Instead of dragging a wooden rowboat over the rocky beach to the waterline, now a person just lowers the boat from a davit mounted on the edge of the deck into the chilly 45-degree saltwater. (Courtesy of Chip Van Gilder.)

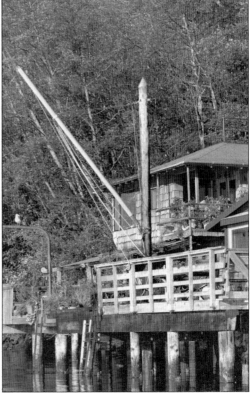

Compare this jib crane to the simple davit at left with the seagull perched upon it. Instead of a chain hoist on the end of a davit, a remote-controlled electric winch pulls heavy cable through a block hung from the end of this jib boom, which pivots around the spar pole. It's no surprise that the owner is a marine engineer. (Courtesy of Chip Van Gilder.)

In the foreground, the first woodshed with a copper roof looks classy with a $1.3 million sewer pump station behind it. In the background, the oldest cabin on the beach is undergoing extensive restoration to its appearance when Otis and Julia Johnson renovated it during the Depression. The Johnson's daughther Jessie Logan said her parents fixed up the place "like a little American embassy in a small foreign country." Since the purchase of the land, home improvements have made dramatic changes in this historic community. Mortgage loans are now common. Granite countertops replace wooden drainboards. Circular stairways wind between floors. Colorful metal roofs replace many roofs of cedar shingles or shakes. (Courtesy of Chip Van Gilder.)

The author's interest in Washington history dates back to his great-great-grandfather, Joseph "Old Cush" Cushman, who opened a store called the Kendall Company in Olympia in 1852. In 1860, Abraham Lincoln appointed him receiver in the general land office, and he remained a federal appointee for nine years. During this time, he joined up with Charles C. Terry to have the territorial legislature grant them and their heirs the exclusive right to harvest shad and alewives in Lake Washington and its tributaries. The act included the right to establish fishing stations on the banks of the Black River, Duwamish River, and other streams. The author felt that the 1974 decision by Judge Boldt to reaffirm Native American tribal fishing rights did not change the inherited fishing rights of the Terry and Cushman families. So in April 1976, Jack Wilkins of the *Seattle Post-Intelligencer* accompanied the author on his quest for shad and alewives under the Aurora Bridge. This newspaper photograph shows the author casting a net borrowed from Nick Tarabochia of Gig Harbor, with the Fremont Bridge in the background. But no shad or alewives were caught that day. (Courtesy of Cary Tolman).

BIBLIOGRAPHY

Adams, Bertha Snow. "She Gaffs Devil-fish," *Sunset Magazine*. February 1924.

Anderson, Warren and John Bailey. "Salmon Beach—A Special Place." The *News Tribune*. June 12, 1976.

Duncan, Don. "Salmon Beach 'City' up for Auction." *Tacoma News Tribune*. March 21, 1954.

Garrison, Ed. "Geologist Says Slide Area Safe." *Tacoma Sunday Ledger*. April 17, 1949.

———. "No Forced Removal Planned." *Tacoma News Tribune*. April 20, 1949.

Gillie, John. "Salmon Beach Homeowners Get Land." The *News Tribune*. October 6, 1977.

Graham, Oscar. *Salmon Beach: A Study in Method*. Senior Thesis. University of Puget Sound, 1976.

Haffer, Virna. *Making Photograms*. New York: Hasings House, 1969.

Hinds, Geff and Bart Ripp. "On The Beach." The *News Tribune*. March 10, 1990.

Jack, Pyle. "Salmon Beach Property Swap Being Explored." The *News Tribune*. January 20, 1984.

Jarrell, Dwight. "Cool 12-Year-Old Hero of Salmon Beach Fires." *Tacoma News Tribune*. August 1, 1969.

Johnson, Bruce. "Salmon Beach: A Fearless Community Survives." The *News Tribune*. January 13, 1974.

King, Timothy. "Salmon Beach Sewer OK'd." The *News Tribune*. July 25, 1990.

Lizberg, Carl. "Beach Cabin." The *News Tribune*. July 10, 1983.

Lund, Roland. "Salmon Beach Retreat." The *News Tribune*. February 2, 1975.

———. "Salmon Beach Photo Legacy." The *News Tribune Sunday Magazine*. June 8, 1975.

Narrows Realty Co. v. State [of Washington]. 52 Wn 2d 843, 329 P.2d 836 (State Supreme Court 1958).

O'Ryan, John. "A New Life on an Old Beach." *Seattle Post-Intelligencer*. May 20, 1979.

Porterfield, Elaine. "Landmass threatens—residents unmoved." *Seattle Post-Intelligencer*. May 2, 2001.

Ryan, Jack. "Remote Salmon Beach: A Century Away." *Seattle Post-Intelligencer*. May 24, 1969.

Salmon Beach Facilities Plan. City of Tacoma, WA: PEI Consultants, Incorporated, 1989.

Scherman, Elizabeth. "Salmon Beach sewers moving after cliffhanger delay." The *News Tribune*. November 27, 1991.

Shomshak, Vern. "H. O. Foss Gift Spurs Salmon Beach Project." The *News Tribune*. January 13, 1970.

Thiel, Art. "Salmon Beach Area Added To Park." The *News Tribune*. September. 9, 1975.

Voelpel, Dan. "Waterfront Park Land Deal Complete." The *News Tribune*. June 11, 1985.

Vogel, Elmer. "Tidal Wave Assails Salmon Beach after High Cliff Topples Into Sound." *Tacoma News Tribune*. April 16, 1949.

Webster, Kerry. "Beer Foam Christens Salmon Beach Park." The *News Tribune*. November 9, 1979.

ACROSS AMERICA, PEOPLE ARE DISCOVERING
SOMETHING WONDERFUL. *THEIR HERITAGE.*

Arcadia Publishing is the leading local history publisher in the United States. With more than 3,000 titles in print and hundreds of new titles released every year, Arcadia has extensive specialized experience chronicling the history of communities and celebrating America's hidden stories, bringing to life the people, places, and events from the past. To discover the history of other communities across the nation, please visit:

www.arcadiapublishing.com

Customized search tools allow you to find regional history books about the town where you grew up, the cities where your friends and family live, the town where your parents met, or even that retirement spot you've been dreaming about.